50 GEI

Nottinghamshire

DAVE MOONEY

AMBERLEY

For Sarah and Eleanor, who came with me to so many of these wonderful places

First published 2019

Amberley Publishing
The Hill, Stroud
Gloucestershire, GL5 4EP

www.amberley-books.com

Copyright © Dave Mooney, 2019

Map contains Ordnance Survey data © Crown copyright and database right [2019]

The right of Dave Mooney to be identified as the Author
of this work has been asserted in accordance with the
Copyrights, Designs and Patents Act 1988.

British Library Cataloguing in Publication Data.
A catalogue record for this book is available from the British Library.

ISBN 978 1 4456 8463 5 (paperback)
ISBN 978 1 4456 8464 2 (ebook)

Typesetting by Aura Technology and Software Services, India.
Printed in Great Britain.

Contents

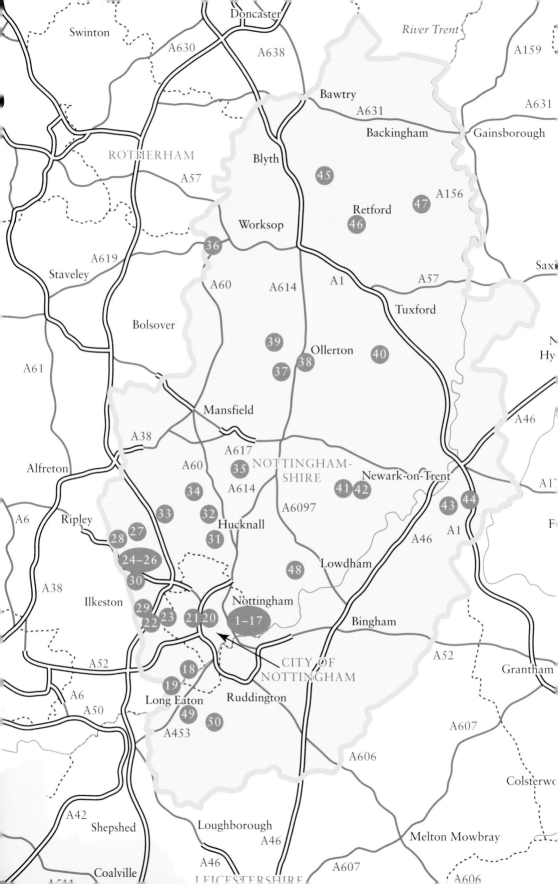

Introduction

For people the world over, Nottinghamshire is associated with the legendary outlaw Robin Hood. One only has to mention Sherwood Forest or Nottingham Castle to evoke a misty-eyed look of romance in the eyes of even the most cynical of tourists.

But the historic county is so much more. It has been the home to scandalous authors, brave poachers and wise fools. It has provided the world with great minds (architects, engineers, mathematicians, poets), great songs have been sung, giant maypoles have been danced around, ale has been quaffed and mushy peas have been elevated to a ridiculous culinary position.

The people of Nottinghamshire are not so easily recognised in the public consciousness as Scousers, Geordies, Cockneys or Yorkshiremen, and yet they have an identity, a dialect (or rather a variety of dialects) and a sense of humour that is as strong and distinct as anywhere else in the country. From the Beauvale martyrs to the Luddites, from Lord Byron to William Booth, this has always been a place for free thinkers – fiercely proud and independent people who are willing to go against the grain. Hopefully, something of the spirit of these people can be gleaned in the short articles contained in this volume.

In this book, I have endeavoured to give a brief introduction to fifty of the greatest things that the county has to offer. There are many gems that I have had to miss out – may St Annes Allotments, the Southwell Workhouse and the Framework Knitters Museum forgive me! I have also tried to eschew some of the more iconic tourist attractions; Nottingham Castle, The Trip to Jerusalem and the Nottingham Council House are all adequately covered elsewhere.

Where possible, I have tried to include things that are free to visit. As a family man living on a budget, I am well aware of the financial constraints that weigh against expensive days out. Where there is a cost of entry, you may rest assured that it will be within the affordable price range of most people – the grounds of Newstead Abbey, for example, may be visited on foot for around £2.

So, come with me now on a journey through time and space as we enter one of England's most engaging and historic counties.

1. Watson Fothergill

The city of Nottingham has its fair share of ugly buildings – unsightly blocks of concrete, thrown up in the middling years of the last century, a tribute to very poor town planning. It's not all bad though. Peppering the city, like sprinkles of gold dust upon a slug, are the works of one of the nation's greatest ever architects.

Born in Mansfield in 1841, Watson Fothergill has a style that is instantly recognisable. Often using red brick, his buildings are a wonderful mixture of medieval, Tudor and Scottish Baronial influences. Turreted, spired and charmingly furnished with leaded windows and ornate sculptures, they stand out from the works of lesser men that surround them.

He designed over a hundred buildings within the city, many of which are still standing, for a multitude of purposes. Among them are private residences,

Fothergill's almshouses.

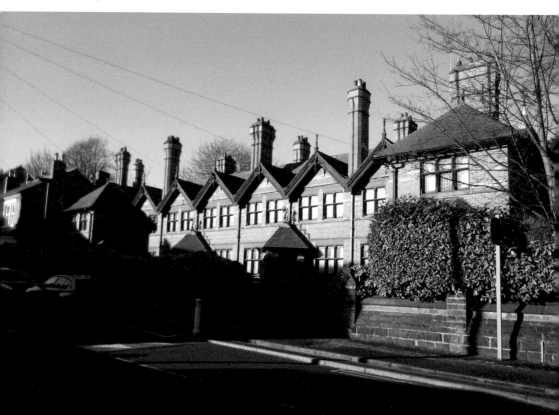

Fothergill's offices.

alms houses, pubs, churches and a bank. The latter (formally the Nottingham Bank) is still there – although it is now a bra shop – and it is overwhelmingly impressive. At first glance, it appears to be nothing less than a cathedral to the laissez-faire capitalism of his day, although a knowing eye might spot the carving of a monkey on the roof – the literal embodiment of the monkey on your back that you would take on if you were to borrow money from the bank.

Other Fothergill buildings have also been put to modern uses that would have been inconceivable in his day. The ground floor of the Nottingham Express Offices now houses various high street chains, whereas the Baptist church that he designed on Woodborough Road is now home to a Pakistani community centre. This is well worth a visit, if only for the reassuringly spicy (and very reasonably priced) meals that they serve on weekday lunchtimes. The chapatis are to die for.

For me though, Fothergill reserved the best of his efforts for his own office, which is situated on George Street. Built in 1893, the office building has the turret, woodwork and gorgeously shaped windows that we would expect from the master. Added to this are tributes to his influences – relief carvings of men erecting buildings in various historical epochs, as well as the statue of a medieval architect, busts of Pugin and G. E. Street and the surnames of his near contemporaries George Gilbert Scott, William Burges and Richard Norman Shaw.

Imagine my horror when, in the July of 2015, a lorry hit the building and seriously damaged some of the brickwork. It remained in a state of ill repair for almost three years, but I am happy to say that it has now been seamlessly restored.

2. Xylophone Man's Memorial Slab

For anyone who lived in or around the city of Nottingham during the 1990s, mention of one particular busker is apt to bring a smile to their face.

For years, Frank Robinson sat outside C&A (now H&M, just down from M&S – it's all most confusing) and entertained the public by randomly tapping away at a small, brightly coloured metallophone. His musical abilities may have been limited (occasionally, he accidentally played the opening phrase to 'When the Saints Go Marching In'), but the people of Nottingham took him to their hearts. Unaware of the difference between a metallophone and a xylophone (one is made of metal, the other of wood) they christened him 'Xylophone Man'.

The tuneless, high-pitched tinkling of the instrument became an indelible part of the soundscape of the city.

When Frank died in 2004, local people expressed genuine sadness. So much so that, the following year, a memorial slab was unveiled at the site of his favourite busking pitch.

I was in my formative years when Frank Robinson was plying his trade and, as a sometime street performer, I'm fully aware of both the joy that he brought to passers-by and the influence that he has had on me. As a personal tribute, I made sure that when my busking partner (a dancing doll named Nancy) made her public début, it was on the slab that marked the musical career of a local legend.

The Xylophone Man's memorial slab.

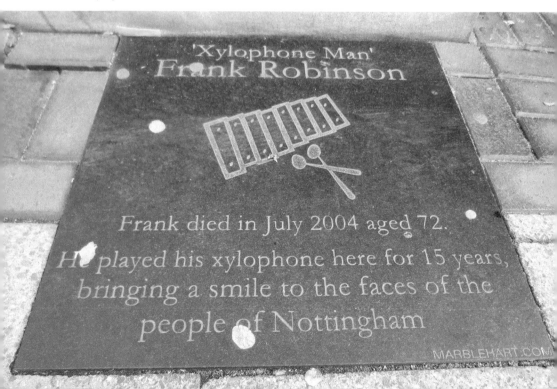

3. Goose Fair

Then haste away, make no delay, to Nottingham repair,
And if you're fond of fun and glee, you'll find it at the fair
 'The Rigs and Fun of Nottingham Goose Fair'
 (A nineteenth-century broadside ballad)

As the summer fades into autumn and the air of crisp, sunny days becomes chill enough to 'mek yer tabs laugh' (make your ears tingle), you will start to hear Nottingham folk saying to each other, with jolly conviction, 'It's proper Goose Fair weather int'it!'

Then, towards the end of September, a large goose appears on one of the traffic islands near the Forest Recreation Ground.

The excitement begins to mount.

Finally, the first week of October arrives and with it, the opening of one of the largest fairs in the country. A dazzling array of rides and spectacles are on offer: from steam-powered carousels and cake walks, to ultra-modern contraptions that swing you through the air at an unbearable rate and all but deafen you with a bass that makes your teeth rattle.

The thousands of visitors to the fair are treated to an overwhelming sensory swirl of lights, music, sounds and smells. Men with microphones call out to you to try your luck at games of chance or skill that are firmly rigged in favour of the proprietor. Endless food stalls offer suspicious looking burgers, brandy snaps, noodles, chips, roasted chestnuts and, of course, mushy peas with mint sauce – no visit to the fair is complete without a styrofoam cupful! Hawkers clutch unwieldy bundles

The sun sets over Goose Fair.

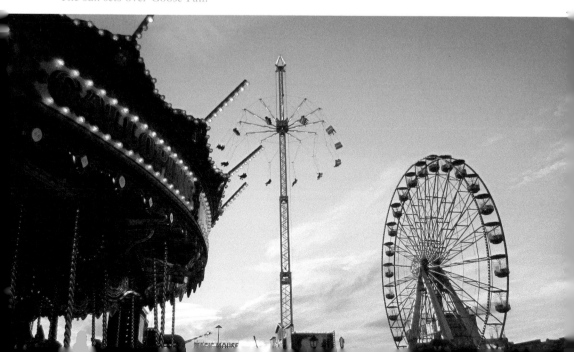

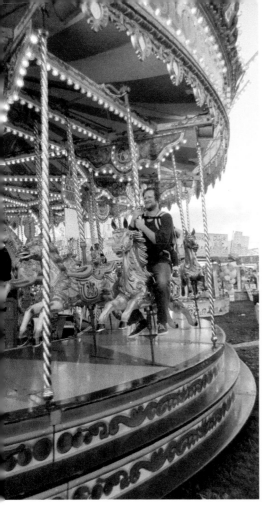

Having a ride on a carousel at Goose Fair.

of helium-filled balloons or man stalls selling a befuddling selection of flashing, spinning, plastic gewgaws.

The famous boxing bouts and 'freak shows', it seems, have fallen from favour in recent years, which is a shame as the latter allowed a friend of mine to offer up the greatest witticism of his life. When I told him that I'd been in a freak show, he replied puckishly, 'Did you win?'

The freak show in question was a shoddy affair of bad taxidermy, tricks with mirrors and the pickled foetuses of deformed animals, but my friend's joke was worth the price of admission.

The fair, which takes its name from the herds of geese that were once marched there from as far away as Norfolk, is of some antiquity, having existed at least as far back as the thirteenth century. For many years, its principle function was as a place for trading livestock and other goods. The cheeses were, apparently, particularly fine. The array of goods available to the visitor is attested to in the aforementioned broadside ballad:

Then see what mountains of fine cheese are piled on the ground,
And geese with cackling music so sweetly sing all around:
And sucking pigs and turkeys invite the hungry elf,
Crying 'come and buy, and then pray try if you can't please yourself'.

As with all such fairs, pleasures would have been mixed with business and it is fun to imagine the sideshows, musicians, tumblers and mountebanks who would once have enlivened the spectacle.

Time has moved on, but the continuous history of the fair is, pretty much, unbroken. It was placed on hiatus during both world wars and during a particularly virulent outbreak of the plague in the seventeenth century. Apart from that, it has been business as usual.

The fair holds a special place in the heart of your humble author. I proposed to my wife at the very top of the big wheel, quite forgetting when planning to do this, that I suffer from a crippling fear of heights.

She said yes, despite my terror.

4. The Arboretum

Set just outside the city centre and adjacent to the bustling Nottingham Trent University campus, the Arboretum is (as the name suggests) a green, tree-filled space perfect for romantic walks, picnicking with friends or chilling out on the grass with a good book. On sunny summer afternoons it is a Mecca for students who come to play at frisbee, acoustic guitar and the (ever tricky) game of love, with the full gusto of youthful abandon.

The Arboretum was opened on 11 May 1852 on land that had been set aside by the Enclosure Act. It was Nottingham's first public park and still has an air of high-Victorian pomp about it. As you roam the winding lanes, between a myriad of

Captured cannons on the Arboretum.

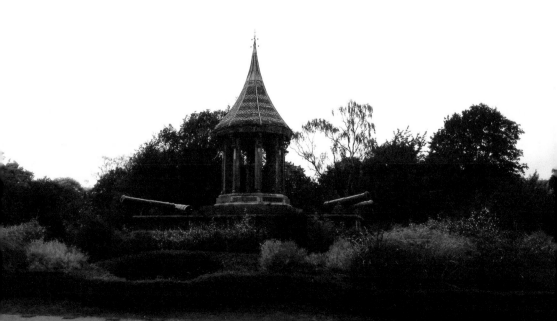

trees (over 830 in total, representing over 220 species and varieties) and gorgeously coloured flower beds, you are apt to stumble upon constant reminders of the mid-nineteenth century.

The heady days of Empire are writ large. A picturesque, Chinese-style bell tower mounted upon a plinth surrounded by shrubs and flowers and flanked by cannons acts as a memorial to both the Siege of Sevastopol and the Anglo-Chinese 'Opium' Wars. Two of the cannons were captured during the siege (the other two are replicas for the sake of balance) and the original bell was taken from a temple in Canton (this has since been removed to a museum and replaced with a duplicate).

Should these reminders of Britain's imperial past not be to your taste, you may be interested in the statue of Feargus O'Conner that stands nearby. O'Conner was the MP for Nottingham between 1847 and 1852. He was also a Chartist – a leader of the working-class movement that campaigned for universal male suffrage.

This statue is the only one ever erected to a Chartist leader, and it is strange that it does not play a more central role in the annual Green Festival, which is held in the Arboretum each September.

This popular event brings together a vast array of campaign groups (from household names like Greenpeace, the RSPB and the Woodland Trust, to local activist organisations). Vegan food is abundant and there is live music on the bandstand and elsewhere around the site.

For the more spiritually minded, the Arboretum also plays host to Nottingham's annual Pagan Pride event. Taking place every August, this has grown to be the largest of its kind in the UK and allows visitors to experience talks on paganism, listen to music and visit a bedazzling number of craft stalls, selling everything from wands to spell books and ceremonial robes.

Personally, what I enjoy most about this green space is the duck pond. Here you can sit and watch the burbling fountain and throw seed to the army of ducks and moorhens that live there. Be prepared to be mobbed by the pigeons who loiter in an old oak tree that overhangs the water.

Saving the world with vegan cake stalls and pedal power at the Green Festival.

Next to the pond is an aviary, which houses a large number of rescue birds – these are generally parakeets and cockatiels. Next to these more modern cages is a large Victorian 'circular aviary'. It now stands unoccupied, but a small sign informs visitors that it was once the home of a local celebrity who went by the name of Cocky. This cockatoo was a popular visitor attraction and was reputed to have lived to the ripe old age of 114.

Should you be exhausted by all this strenuous tree-based activity, then you can always sit down for a cup of tea and some rather delicious cake at the Arboretum Café that is located in the fine-looking Waverley Lodge. This is a listed building that once housed the head of the grounds. It is also a place where you can stock up on more bird seed for the ever-ravenous hordes of ducks and pigeons.

5. Bromley House Library

It is very easy to miss the entrance to the Nottingham Subscription Library. It is sandwiched between a charity shop and a newsagent's on Angel Row, just off the Old Market Square. The only real clue to its existence is a board that stands on the pavement outside, offering weekly tours of one of the city's 'hidden gems'.

Once inside the building (members only, if not pre-booked on a tour), the lucky visitor is treated to a bibliophile's paradise – a veritable Shangri-La for the lover of the written word.

The library was established in 1815 and has been amassing books ever since. Volumes ancient and modern are available to peruse and to borrow. Your humble author has been a member for a number of years, and some dusty tome worn by the passing of the centuries is often to be found on his bedside table. There are books everywhere, organised according to some unfathomable system: one room

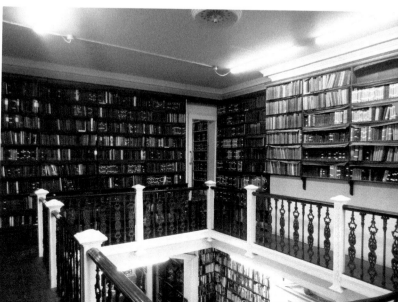

So many books
and so little time!
Bromley House.

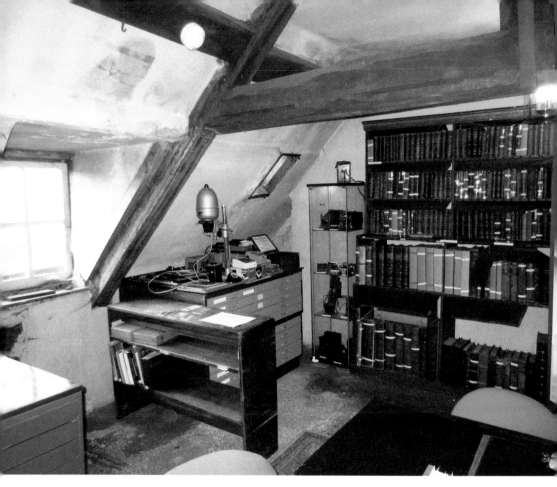

The Bromley House attics.

offers works by long-forgotten poets and Victorian traveller's tales, while another is devoted to the natural sciences and is resplendent with lovingly illustrated works by Victorian curates, who were naturalists in their spare time.

A mezzanine level, its floorboards smoothed by countless feet, is reached by a spiral staircase. Built in the carefree days before building regulations, and without a central column, it can only support one person at a time.

Scattered around the library are various wonders. In the attic are a number of antiquated cameras; a display erected in honour of the fact that the building once housed the city's first ever photographic studio. Elsewhere, you will find a 'meridian line': a straight line on the floor, traced out with metal and glass, that allows the observer to tell the time according to where the sun falls along it. Nearby, an old clock (built before the railways necessitated standardization across the nation) tells you what time it is in different parts of the country.

There are binoculars and bird books beside the windows at the rear of the building, so that patrons might sit and spot any winged visitors to the walled garden belonging to the library.

The garden has a selection of trees and plants and some – rather uncomfortable – furniture. On a sunny day, it provides a relatively quiet spot to sit and read.

Members are treated to a whirl of social activities, with regular guest speakers (I have been known to say a few words), tea parties, a carol service and knitting and games clubs, to name but a few.

6. Bendigo's Grave

With two league football clubs, the National Ice Arena and the prestigious Trent Bridge Cricket Ground all located in the city, Nottingham is undeniably a sporting hub. The untutored may think of Carl Froch or Torvill and Dean when they are asked to name local sporting heroes, but for the connoisseur, one name stands out from the rest: Bendigo.

William Abednego 'Bendigo' Thompson was born in Sneinton in 1811. His upbringing was hard and harsh. One of twenty-one children, he was raised in one of the worst slums in the country (slums that would later help to inspire another great local – William Booth – to set up the Salvation Army). Thompson spent some time in the workhouse and on the city streets selling oysters. By his late teens, he had turned to bare-knuckle boxing as a way of earning money. Small in stature he may have been, but Bendigo was strong and he was fast.

It wasn't long before he came to national prominence. Predating Muhammed Ali by over a century, Bendigo was possessed of a similar lovable charisma – a quality that would earn him the moniker of 'the Nottingham Jester'.

The lion and the lamb: Bendigo's grave.

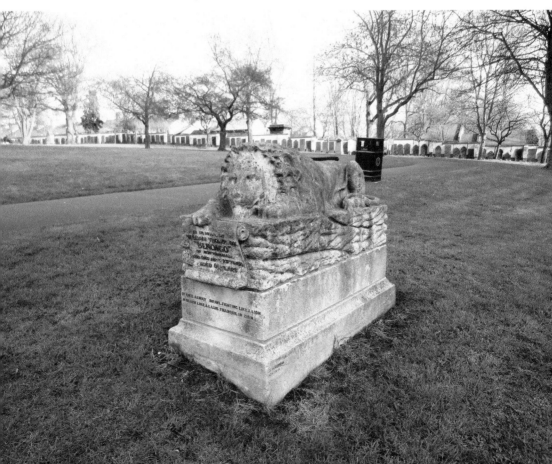

He retired at the age of thirty-nine, an undefeated prize fighter who had managed to win two belts and four silver cups.

A hard drinker with a fiery streak, Thompson was frequently in trouble with the law. It was during the wilderness years that he fell in with the 'Nottingham Lambs' – political agitators and thugs for hire.

In later life, he found God and became a preacher, delivering the same firebrand passion to his proselytising that he had always given to his fighting. His congregations were huge and, when the end finally came, his funeral procession was a mile long.

His grave is situated at the Bath Street Rest Gardens. This was formally a burial ground, although redevelopment has meant that all of the other gravestones have been removed. Bedigo's final resting place is situated by the fence, overlooking the road. It consists of a plinth, upon which rests a slumbering lion. Beneath this is an inscription:

> In life always brave,
> Fighting like a Lion;
> In Death like a Lamb,
> Tranquil in Zion

This is usually read as a reference to the religious zeal that he expressed later in life, although I have heard it said that the 'Lamb' in question may refer to his shady connections in the Nottingham underworld.

7. Stonebridge City Farm

Even in the heart of Nottingham one can still hear the distinctive bleating of sheep or the ridiculous gobble of a turkey. This may be the biggest city in the East Midlands, but there is always room for a little oasis of country living.

Stonebridge City Farm is an incredibly worthy community project that serves multiple purposes: it provides volunteering opportunities for adults with learning disabilities, it provides a space for various groups and workshops and (perhaps most importantly of all) it provides urban children with a place to go and see farm animals up close. There is little in life to match the look of joy on the face of a child who has just bought a bag of animal food from the on-site shop and is in the process of feeding it to a hungry goat.

All of the usual farmyard favourites are there: cows, sheep, ponies, etc. A pair of delightful black pigs lumber around their pen or laze in the sunshine, while fine cockerels crow in the poultry pens and a collection of finches, budgies and quails look fetching in their more exclusive accommodation. A small shed houses some guinea pigs and rabbits that may be petted for the nominal price of a token.

Home-grown produce is sold in the shack that acts as a shop, while hearty and inexpensive food is available from the cafeteria.

This is urban life as it should be – rural!

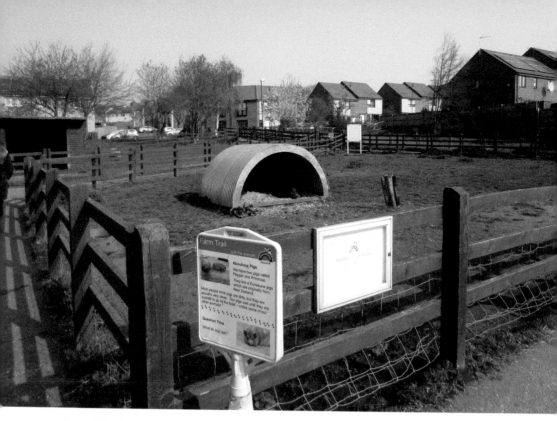

Above: The Stonebridge pig sty.

Below: Aww! Lambing season at Stonebridge.

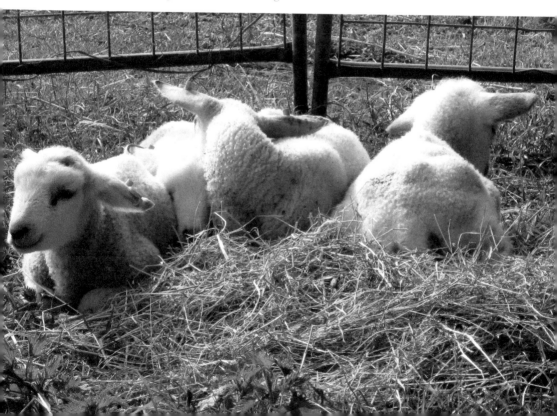

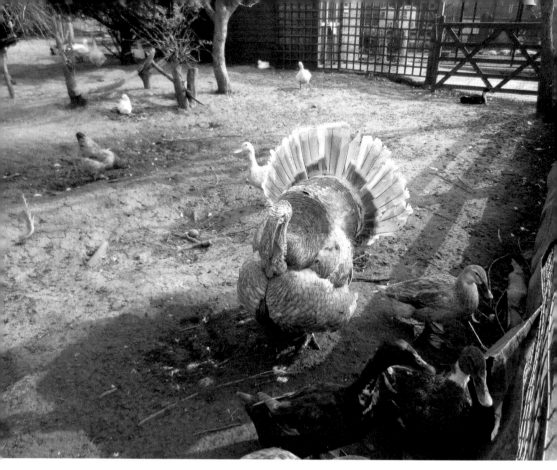

Definitely less cute than the lambs, but I'm sure his mother loves him! Stonebridge City Farm.

8. The Mushy Pea Stall

It is getting increasingly difficult to find an unpretentious bite to eat in our city centres, but fear not, there is still a haven of straightforward sanity left in the world. There are no frills and fripperies at the mushy pea stall.

Located at the back of the fish market, on the upper level of the Victoria Shopping Centre, the stall looks like a peculiarly working class, English take on a Japanese sushi bar. Patrons sit on high stools around the counter, where there are communal pots of salt and pepper and bowls of watery mint sauce.

One can buy pasties, pies, cockles, whelks, faggots and – of course – mushy peas. The latter are served in bowls (two sizes are available) and are to be eaten with several ladles full of mint sauce doused over them.

Liverpool may have its scouse, London its pie, eels and mash, and Melton Mowbry its pork pies, but this is definitely Nottingham's dish of choice. There has been a pea

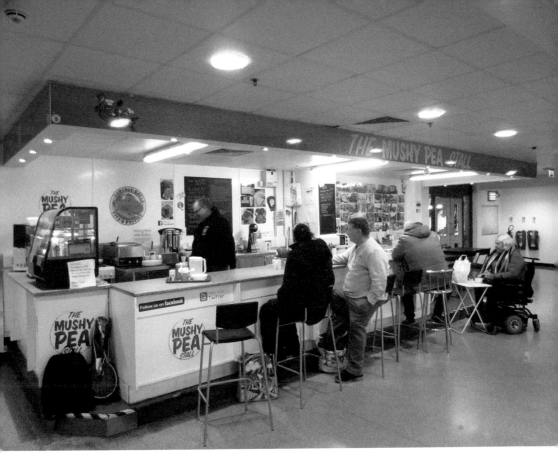

Above: A regional delicacy in the Victoria Centre Market.

Below: Heaven, thy name is peas!

stall in the city since the 1950s (interestingly, this predates the term 'mushy pea', which wasn't coined until the late 1960s). Back in those days, it was to be found in what was then the Central Market. With the coming of the Victoria Centre, however, it moved to its current location.

For a period, it did close down, but you can't keep an institution like that under for long. Having reopened in 2016, the stall has amassed an army of loyal regulars and interested visitors, all keen to taste the delicacy that is so highly esteemed by the people of this city.

9. The Emett Clock

There are few things that I find quite so depressing as an indoor shopping centre, and yet if you can look past the crass commercialism and the dead-eyed consumption of Nottingham's Victoria Centre, you will find a true gem. What is more, it is a gem that has brought pleasure to generations of local children, your humble author included.

Below left: The Emett Clock.

Below right: Emett Clock detail.

The *Aqua Horological Tintinnabulator* (more commonly known as the Emett Clock) was built for the opening of the shopping centre in 1973 and was designed by the Rowland Emett – a cartoonist and purveyor of whimsical automata and moving sculptures. It is 23 feet tall and is in a state of constant movement; jets of water spew from long copper pipes into the 'wishing well' that surrounds it, while a wheel decorated with metallic frogs and butterflies rotates through the fountains. Higher up, squirrels carry out a series of comic activities (riding on a fish, pushing a pram and sitting on the back of a boat 'manned' by a peacock) as they spin around the central column. Every quarter of an hour, copper petals, located half way up the structure, fold back and a band of two-dimensional, silver-coloured, woodland creatures bursts into life – dancing in a circle and playing a piece by Jean-Phillippe Rameau on instruments that obviously would not make the sound of the harpsichord that you can hear. No wonder I loved it as a child and waited anxiously by it for the hour to strike!

Obviously, people throw money into the water that surrounds the clock and make wishes. I don't know how many of the wishes come true, but the coins are regularly collected up and donated to local charities. So far, the total given is well into the five-figure mark.

So beloved is the clock that a friend of mine has named his son Emett in its honour. Currently, this is the only person that I know of who is named after a timepiece (although in my younger days, I did have two grandfathers).

10. The Rock Cemetery

Situated just outside of the city centre, the Church (popularly known as 'The Rock') Cemetery is a romantic, 13-acre necropolis that has been used as a burial ground since the middle of the nineteenth century.

It may not sound like the most picturesque place for a stroll, but a wander along the narrow lanes that wind around sandstone outcrops, into which caves and niches for tombstones have been cut, will reveal an eerie beauty that is hard to resist.

The main avenue, which runs straight along the top of the cemetery, parallel to the Forest Road, takes you past a bewildering mass of monuments: broken pillars and stone angels riven with despair are packed together so tightly that one might struggle to draw a funeral shroud between them.

Away from the main drag, the footpaths begin to meander and the graves become less close together. Large, elaborate structures, their inscriptions often worn to illegibility, mark the final resting places of the great and the good of the city's past – here a wealthy Victorian drowned off the coast of Italy, there someone who did not survive the First World War. The lucky ones died peaceably in their beds.

Eventually, your steps may take you to a large, steep, walled amphitheatre. Sadly, this is now gated, but it is pleasant to look down onto the tops of the trees.

For me, the most attractive (if that is the right word) spot in the whole of the cemetery, is located close to Mansfield Road. Here, one is sheltered on all sides by

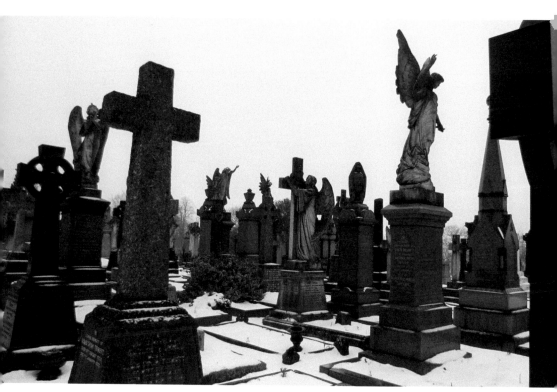

Above: A city of the dead – the Rock Cemetery.

Below: Caves in the Rock Cemetery.

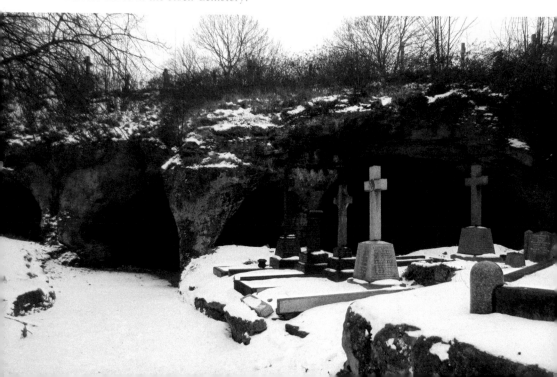

sandstone walls. Deep caves are cut into these (although they are all either bricked up or fenced off). When excavation began on the site, following the 1845 Enclosures Act, the caves were discovered and heralded as being associated with the legendary outlaw, Robin Hood. They were – very briefly – something of a tourist attraction. In reality, they were the result of eighteenth-century sandstone mining, but that didn't stop the purveyors of picture postcards from making a killing (no pun intended).

Surrounded by graves and caves, a flat area of grass makes a perfectly macabre spot for a picnic, safe in the knowledge that the dead have no interest in your crisps and sandwiches.

11. St Mary's Church

Nottingham's Lace Market is, without doubt, the prettiest part of the city. Cobbled streets run between the tall, majestic buildings that once throbbed with the activities of the local lace industry. And at the heart of the area is the magnificent church of St Mary.

St Mary's Church in the Lace Market.

Porch carving, St Mary's Church.

St Mary's is mentioned in the Domesday Book, although much of what may be seen today was built in the fourteenth and fifteenth centuries. An engaging edifice, it stands surrounded by old buildings that are mere striplings in its presence.

The churchyard is attractive enough, but the main joys are to be found in the south porch. The exterior door is flanked by beautifully weathered medieval carvings. More engaging masonry may be found within, but here it is complimented by the presence of an impressive, early twentieth-century bronze door.

Through this door is the main body of the church – a large and imposing space, but one of curious contrasts, the conventionally attractive stained glass offset by the contemporary Christian art that is to be found on the walls. The solemn weight of antiquity hangs over the place and yet this is at odds with the modern chairs that stand on either side of the isle (their presence is a great pity in my opinion – I like few things more than a well-worn pew).

At the rear of the church, on either side of the large, main doors, are the usual reasons for my visits. Here, on top of tall columns, are the lion and the unicorn. The lion is an affable-looking beast, painted gold and proudly wearing the crown that he had beat his adversary all around the town for. The unicorn, by contrast, is hilarious. With doe eyes, limp hoof and the reddest lips that you have ever seen, he looks simply fabulous. It's a wonderful statue that looks as though it should come alive at any moment – and when it does, it's going to speak like Dick Emery.

The lion may have won the crown, but the unicorn has won my heart – 'Ooh, you are awful. But I like you!'

12. Sneinton Dragon

When strolling along the streets of Sneinton, be sure to keep your wits about you...
Here Be Dragons!

In 2006, locals were asked what form they would like a new piece of street art
to take. The answer that they gave was, perhaps, a surprise to the authorities; the
good people of Sneinton wanted a dragon. Nottingham-born artist Robert Stubely
was given the task of fulfilling this wish, and I am sure that he did not disappoint.

With a 15-foot wingspan, the stainless-steel monster resides on top of a tall pole,
surrounded by trees, on the corner of Sneinton Hermitage and Manvers Street.
These are busy roads and the traffic rumbles by as the beast glares out ferociously
at cars, buses and pedestrians alike. The trees that surround it give an ever-changing
backdrop to the sculpture and it is a constant joy to see it in different seasons –
surrounded by blossom, leaves or bear branches depending on the time of year.

And if this alone isn't worth the visit, just a minute's walk along Sneinton
Hermitage will take you past some very pleasant looking caves, carved out of the
sandstone. These were once dwellings for some of the poorest people in the city but
now appear to be nothing less than a lair where a dragon might keep his horde.

A dragon among the blossom, Sneinton.

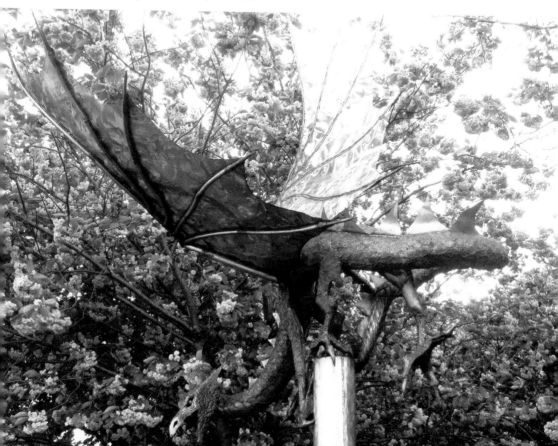

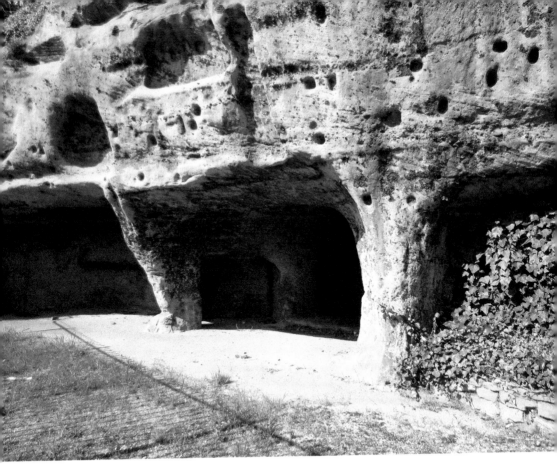

The hermitage caves, Sneinton.

13. Notintone Place

Prior to the Industrial Revolution, Sneinton was a small village, removed from Nottingham itself by clear, green space. All of that was to change when, in the early part of the nineteenth century, this land was sold to developers. Cheap housing sprang up to accommodate factory workers, and one of the worst slums in England was born. Overcrowding was rife and tenants lived cheek by jowl in a state of appalling poverty and degradation.

These conditions – witnessed in the early life of the firebrand preacher William Booth (1829–1912) – could scarcely have failed to affect him and it is, perhaps, unsurprising that he went on to form one of the most important (and controversial) religious movements to have emerged in the last 200 years: the Salvation Army.

Whether you see them as a friend to the poor and a soundtrack to your Christmas, or as tambourine-waving purveyors of 'Blood and Fire' piety, it is hard to deny the global impact that the 'Sally Ann' has had.

Given the movement's importance, it is surprising that the birthplace of its founder is so modestly signposted. Blink and you will miss the arrow pointing to Notintone Place.

Half-covered by ivy, a Salvation Army badge, bearing the famous emblem and motto, is affixed to the outside wall of a small courtyard. Upon passing through the gate, visitors are greeted by the sight of a very attractive tree, a mock-Victorian street lamp and an imposing statue of Booth, arm raised in a preacher's attitude as he rails against poverty and the 'demon drink'. Behind him is a row of tall, Georgian houses. One of these was the site of the great man's birth, although the entire row has now been knocked through and is used as a museum dedicated to his life and works.

The museum is rather modern inside, but it does have some interesting exhibits and gives a flavour of what both Booth's childhood and conditions in the local area would have been like.

I can't help but wonder – as I look up at the statue of the eminent Victorian filled with too much zeal to allow any room for humour – what he would have thought of me, the author of a book about pubs. I may not have taken the pledge, but I am rather partial to a brass band.

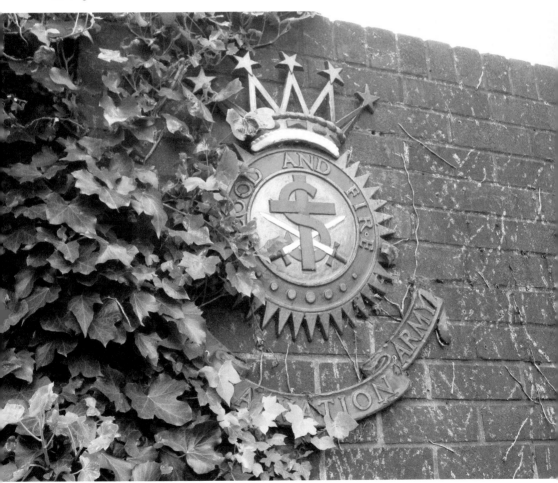

Blood and fire with the Sally Anne, Notintone Place.

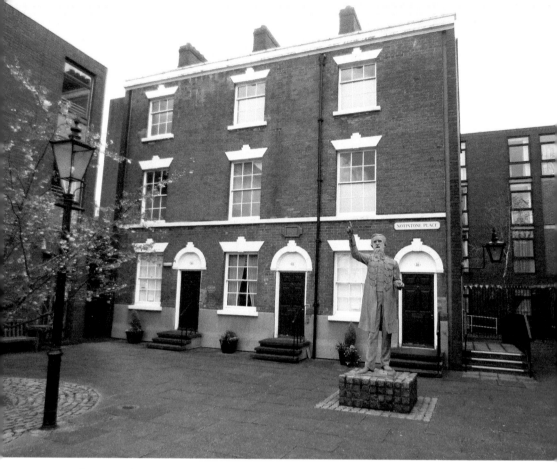

William Booth's birthplace, Notintone Place.

14. Green's Windmill

In 1823, the largely self-taught mathematician George Green published *An Essay on the Application of Mathematical Analysis to the Theories of Electricity and Magnetism*. This snappily titled work revolutionised this relatively new field (no pun intended), provided a basis for future research and is still vital to the study of mathematical physics to this day.

Green's theorem is undeniably useful in the calculation of two-dimensional flow integrals. I have no idea what that means, but it sounds jolly important!

Green's achievements would be impressive enough, even without taking into account the fact that he was a miller, who had only ever received about one year's worth of formal education.

The mill that belonged to the Green family dominates the Sneinton area of Nottingham and can be seen from many parts of the city. It was built by George Green senior in the first decade of the nineteenth century. In 1829, it was inherited by his mathematical son, George Jr, who had his mind on higher things and found the work tedious. Despite this, he kept the mill running until his death in 1841.

The following century saw the mill falling into ever greater levels of disrepair, until it eventually caught fire in 1947. For decades, it stood burnt out and derelict.

Eventually, it was acquired by Nottingham City Council and – after extensive renovation work – was opened to the public in 1986.

It is now a fully working windmill. When the weather conditions are right, its majestic sails can be seen sweeping the sky over Sneinton. The mill, and the green space around it, add a pastoral, village feel to what is actually a heavily built up, urban area.

It is free to enter the mill (though donations are encouraged) and it is a real treat to watch the milling process. The dusty, flour-covered interior of the building and the sheer oddness of watching the sails drift past the windows make a visit more than worthwhile, although the steep ladder-style stairs may prove a little much for some visitors, especially those with small children or poor mobility.

Safely on *terra firma*, the visitors' centre contains a number of interactive physics-based activities. It is astounding to find out just how much electricity is generated by the human body! There is also a gift shop where you can buy – among other things – flour that is milled on-site. There are separate areas for group activities lead by the staff. These will either be advertised in advance or may be privately booked. I accompanied a group of children there on an outing and they were taught to make fruit cupcakes. A splendid time was had by all!

A community garden is situated around the side of the mill. It is very pretty, especially in late summer when everything is ripe for harvesting. It is here that I think I saw the biggest sunflower that I have ever seen. It was being visited by some rather over-awed bees, amazed by a bloom that, to them, must have been relative in size to a cricket pitch.

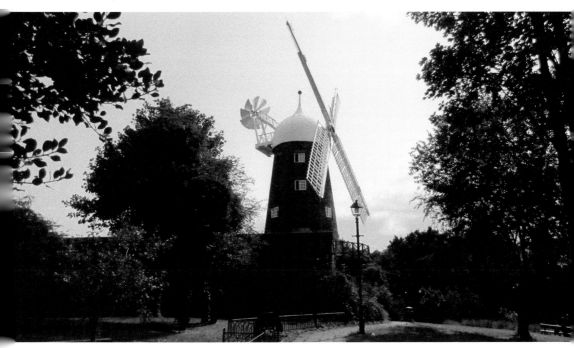

Green's Windmill.

The bees are making the most of the community gardens, Green's Windmill.

15. Trent Bridge and the Victoria Embankment

The main crossing over the River Trent in Nottingham is via Trent Bridge. Here, motorists are treated to a view of a river that has become lazy and sluggish by this point. One bank is dominated by a stadium, emblazoned with red and white – the City Ground – home to Nottingham Forest Football Club. Nearby is the world-famous cricket ground that takes its name from the bridge, while down below, out on the water, rowers whizz up and down like giant insects on the surface of a pond. There can be few better places for those who come in search of the sporting life.

Personally, I am a habitual pedestrian and, as such, am treated to a view of the intricate ironwork coloured in blue and gold from the safety of the Victoria Embankment. Under the bridge, on the wall by the footpath, are high water marks and dates that show the years when the river burst its banks.

The embankment runs along the city side of the river (ironically the City Ground is on the other side, meaning that it is in the county, whereas the Notts County ground, Meadow Lane, is in the city). It is a perfect place for a walk. Ducks and swans paddle in the water and an avenue of trees rustle amiably in the breeze.

Away from the water, on the opposite side of the road, stands a huge gate, which commemorates those who died in both world wars. This is the entrance to a memorial garden. Here you will find floral displays, water features and the Empress of India.

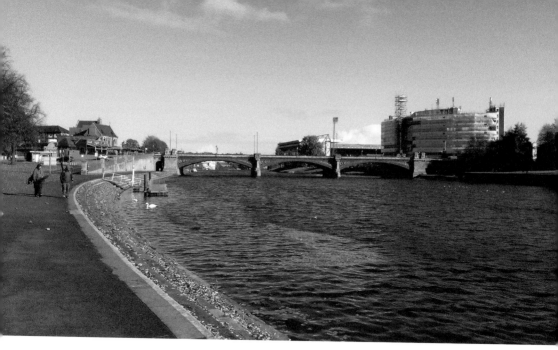

Above: Trent Bridge –
note the City Ground,
just visible on the far
side of the river.

Right: The Empress
of India, Victoria
Embankment.

The statue of Queen Victoria once stood just off the Old Market Square, right in the heart of the city. Now she waits here – largely forgotten – no doubt contemplating the fact that the sun has finally set on her magnificent empire, as the pigeons relieve themselves on her head.

In early August each year, the embankment plays host to the Riverside Festival – a free event that treats the people of Nottingham to three-day orgy of music, fairground rides, beer and pots of mushy peas with mint sauce.

In September, the Robin Hood Marathon begins here – no doubt allowing many a runner to burn off the excesses from the previous month.

A walk along the county side of the river, heading away from Trent Bridge and towards the City Ground, will take you past the Nottingham Boat Club. It is a tiny little clubhouse overlooking the water. In 1971, Led Zepplin played a free gig here – an event that has become the stuff of legends.

Carry on walking and you will eventually come to an open, green space. From here you may see the sails of Green's Windmill caressing the sky or the river cruiser – the *Nottingham Princess* – carrying drunken office workers who are out on a beano. Go further still and you will reach Holme Pierrepont and the National Water Sports Centre.

Was there ever a stretch of water so fraught with reminders of how little exercise one does?

16. St Barnabas Cathedral

As it is within the diocese overseen by Southwell Minster, Nottingham does not have an Anglican Cathedral. There is, however, the rather fine Catholic Cathedral of St Barnabas.

It is of relatively modern construction – having been opened in 1844 – following the removal of most of the restrictive laws governing Catholic observance. The architect was none other than Augustus Pugin, whose other works include the Houses of Parliament and the sublime Church of St Giles in Cheadle, Staffordshire. Pugin was one of the pioneers of the neo-Gothic movement and his buildings are filled with a mock medieval splendour. St Barnabas was no exception.

I am sad to say that I was not around prior to the 1960s, to see the interior of the cathedral as Pugin planned it. As with so many of his buildings, St Barnabas was originally a riot of colour and intricate design. The sumptuous reds, blues and golds and detailed statuary may still be seen in parts of the building – especially in and around the Chapel of Our Lady – but much was removed or covered up, following the Second Vatican Council's decision to bring the church into the twentieth century.

This act of cultural vandalism aside, the building is still impressive in its own rather plain way. The white walls offer a clean, airy feel to the place. While I cannot pretend that I do not prefer some of Pugin's more intact works, I would be lying if I said that this is not a beautiful place to visit or to sit in quiet contemplation.

One of Pugin's master strokes – the Catholic cathedral in Nottingham.

17. The Park Tunnel

One of my favourite tricks when showing people around Nottingham is to take them through the gated residential parking area that is just up the road from St Barnabas Cathedral on Derby Road. As one walks through the area, surrounded by ugly modern buildings, one is compelled to descend on a ramp under the concrete auspices of what appears to be a multistorey car park.

It is at this point that the unsuspecting visitor either drops down the rabbit hole or enters Narnia, depending on their children's book of choice. (I prefer the former.)

The ramp leads down into a huge arched tunnel carved out of sandstone. Midway down this is a wide circular space that is open to the sky. Imposing houses that are almost the archetype of haunted mansions hang over the tunnel, lending it a creepy grandeur that could never be guessed at by my guests.

The tunnel was built in 1855, under the instructions of the then Nottingham Castle resident, the Duke of Newcastle. It was intended to give access to horse-drawn carriages to the Park Estate – Nottingham's newly developed home for the excessively wealthy. It is still frightfully posh, even to this day.

While the tunnel is an impressive and attractive feat of engineering, it was a failure in one important respect: the gradient – 1:14 – is too steep to allow it to be used by horse and carriage! It is, however, still used by pedestrians, cyclists and skateboarders, and it does make an excellent surprise for the unwary.

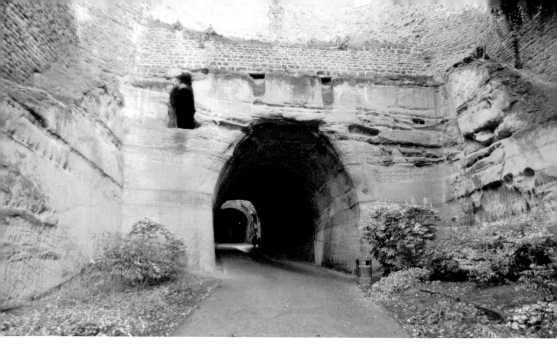

Narnia in a car park – the Park Tunnel.

18. Beeston Carols

The small town of Beeston is always a bustling hive of activity. Its proximity to the international University of Nottingham has made it the home to a large population of Chinese students, and cafés selling bubble tea and aromatic dishes are advertised along the high street on sandwich boards written out in exotic Oriental script.

From the perspective of the early twenty-first century, it is hard to picture the bleak conditions that existed in the town during the Industrial Revolution. Poverty was endemic and – with no welfare state to fall back on and no workers' rights to protect employees – a small spell of ill fortune or ill health could lead to destitution. In the 1820s, the Beeston Methodist Benevolent Society was set up to collect money for the unemployed at Christmastime. In the early days, this was done simply by asking for donations. It was only in the 1870s that some bright spark had the idea of singing carols. They've been singing ever since.

The Beeston Methodist Church's Carol Choir sing around the streets of the town on three occasions in the week leading up to Christmas, including on Christmas Eve. They continue to raise money for the benevolent fund, which is still sadly needed, even after all these years. They also have a practice session in one of the local pubs, which is where I met up with some of their members, including the choir's conductor, Andy, and one of its longest-standing members, Neville.

Neville's grandfather had performed in the choir at the turn of the twentieth century, when they only used to go out for one mammoth singing session on Christmas Eve. 'Singing would start at seven in the evening,' he informed me, 'and would continue around the streets of Beeston until five o'clock on

Christmas morning, when everyone would go back to the Methodist Church for a pork pie breakfast.'

Nowadays, they have to finish by ten as they have received complaints about the noise! The carols that are sung are a mixture of familiar favourites and more unusual festive gems, some of which are unique to Beeston. One of the local songs is a very fine variation of 'Sweet Chiming Christmas Bells', which, for my money, is far better than the more famous examples that are to be found in Yorkshire.

There are also any number of versions of 'While Shepherds Watched' in the repertoire, all using the same lyrics, but set to a variety of different melodies, including, I was surprised to discover, 'On Ilkley Moor Bah'tat'.

The songs were handed down orally until around forty years ago, when Andy and his father made an effort to write them down and work out what was actually being sung.

'It was an all male choir up until the First World War,' explained Neville. 'With the menfolk away, the women had to carry it on, and so they added harmonies that

Singing the words of one song to the tune of another! Carols in Beeston.

suited their voices.' As all of this was done on an *ad hoc* basis, Andy and his father had their work cut out to figure out what was actually being sung.

It's certainly a family affair. Neville's son is a keen member of the choir and his grandson is expected to join as soon as he is old enough.

Personally, I can't think of anything more festive than gathering together to share songs and good cheer on a cold December evening. Through their carols and the money that they raise, this is choir that is definitely spreading goodwill to all mankind.

19. Attenborough Nature Reserve

In 1929, the gravel extraction company CEMEX began work at their huge site, not far from the quaint village of Attenborough. In time, the gravel pits that were created, filled with water and a series of artificial lakes appeared. In 1966, these lakes were opened as a nature reserve by my childhood hero, the coincidentally named, David Attenborough.

The nature reserve is now run by the Wildlife Trust and currently covers 145 hectares, with more 'land' being added as new gravel pits are created. In 2006, *BBC Wildlife Magazine* ranked it ninth in their top ten eco destinations in the world!

It is certainly visually stunning, with huge expanses of water surrounding a maze of lanes that meander around the reserve. The skyline is dominated by the imposing, and strangely appealing cooling towers of Ratcliffe-on-Soar power station, as well as the more conventionally attractive spire of the Attenborough village church.

One of the residents at Attenborough Nature Reserve.

Attenborough visitor centre.

The lakes have attracted over 250 varieties of bird and hides have been placed at convenient spots to allow twitchers to covertly observe them. As well as the standard fare, you might be lucky enough to see sawbills, sea ducks and cormorants. There are also kingfishers, grebes, teal and – for the more mammalian inclined visitor – otters, bats, shrews, voles and harvest mice.

If arriving by car, the visitor will find themselves immediately mobbed by the hordes of Canadian geese, ducks, coots and swans that hang around the entrance to visitor centre, waiting to mug picnickers of their lunch. Duck food may be purchased (very cheaply) in the centre and a few handfuls – judiciously thrown – will soon have you surrounded by a honking, quacking and pecking sea of birds.

The visitors' centre itself contains a café, toilet facilities and, what my family describes as, 'the best toy shop in Nottingham'. Here, an array of cuddly animals, puppets, children's activities and books may be purchased, all of which aim to foster a love of conservation and the natural world in the young.

A casual ramble through the reserve may eventually bring you to the banks of the River Trent. This is a particularly pleasant stretch and one may follow it either upstream to Beeston Marina and the nearby Heritage Centre, or downstream for a much longer walk to the equally pleasant Trent Lock.

20. Wollaton Hall

Few Nottingham residents can have escaped unscathed from childhood visits to the peculiar house of horrors that is Wollaton Hall.

The Elizabethan country house – once the home of the Willoughby family – is situated within the attractive grounds of Wollaton Park, on the outskirts of Nottingham.

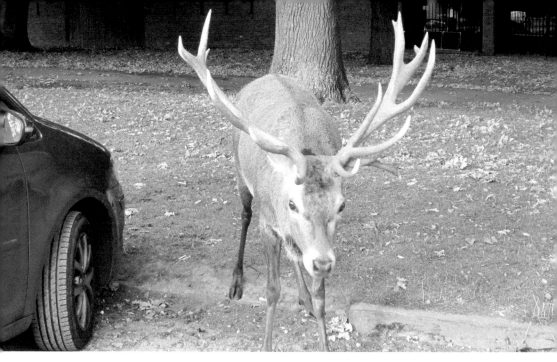

The car park attendant is a little bit scary! Wollaton Hall.

On summer days, it is breathtaking. In winter, it carries a damp, melancholy loveliness all of its own. Deer roam the park, or sit about in herds, chewing at the grass. On the lake, ducks, coots, geese, swans and moorhens cackle and fluster after the seed thrown to them by visitors.

Around the house itself are picturesque gardens, a glass house full of tropical plants and outbuildings, which house an industrial museum. Spires and turrets loom over the visitor and seemingly endless carved figures decorate the walls.

Such is the imposing majesty of the building, that it was given a starring role as Wayne Manor in a recent Batman film.

The hall is the home to Nottingham's natural history museum. Within these walls are the stuffed animals that both engaged and terrified your poor author – and many other Nottingham residents that I have spoken to – in the sensitive years of early childhood.

A lofty and spacious great hall forms the centrepiece of the building. The ornate ceiling is worth studying in detail. This can best be done from the first-floor gallery, although a handy mirror on the ground floor allows you to take in a view that can only normally be seen with excessive craning of the neck.

Other rooms are given over to a gift shop, a collection of period furniture and costumes and a vast array of taxidermy animals, skeletons and mounted heads.

The rooms are moved around relatively regularly, except for the 'bird gallery'. This exhibition has been in situ since the 1930s. Here, in dusty old wooden cases, long dead birds stand frozen in time – acting out meticulously constructed tableaux. Over the display cases, the heads of buffalo, gazelle, zebra and a strange, dragon-like monster called a gharial, gaze down on the visitor with glassy, lifeless eyes.

Perhaps the biggest draw of the museum is the African gallery. In it, warthogs, hyenas and leopards wallow in a watering hole or lounge on the savannah. The chirruping of insects fills the air, and the lighting changes, creating the illusion of the

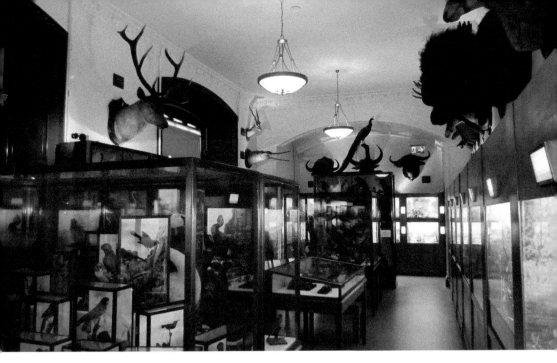

passing of equatorial day. To one side stand a huge pair of elephant tusks and a giant, slightly moth-eaten looking giraffe.

In a case on his own is the horror of horrors: George the gorilla. When I was a child, he had lived downstairs, at the end of a corridor, waiting to devour me. He was famous once: a touring attraction on the Continent, in the heady Victorian days when the average European was unlikely to ever see a living gorilla. The taxidermist had certainly never seen one! George looks nothing like any animal that has ever walked the earth. His mouth is open in a permanent scream, his eyes turned down to meet those of any small child that is compelled to look back at him in fear.

Apparently, it would be possible to restuff him and make him look like one of the gentle giants whose skin he wears. But that would rob Nottingham's parents of a vital tradition: the fostering of George-inspired nightmares. We've been doing it for generations – why stop now?

21. The Hemlock Stone

In 1848, Henry S. Sutton published a lengthy poem describing the feelings of awe that he experienced when visiting the Hemlock Stone – a large, pillar of rock that stands on a hillside near Bramcote. He imagined the countless generations that the stone had witnessed:

What eyes innumerable, O aged stone,
Have gazed, and gazed, thine antique form upon!

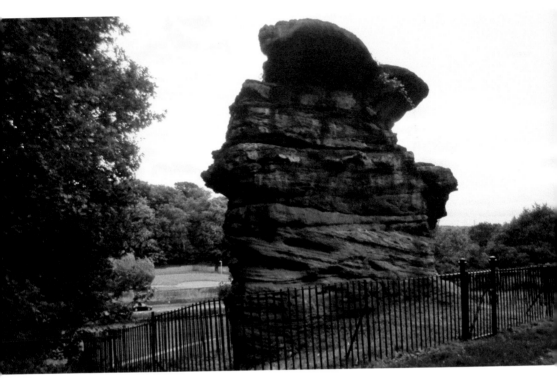

The Hemlock Stone.

He goes on to describe the 'woad-dyed savage', the Roman soldier, the medieval knight, the Cavalier and the Roundhead, who may all once have visited the mysterious rock.

Lovers and maidens: lords, and squires, and pages:
Serf, farmer, village-fool. Ages on ages
Of human life hast seen thee onward glide.
At last I stand upon thy withered side,
Another drop in that still flowing tide.

And the tide is flowing still. Sutton is now as remote a figure to us as the Roundheads and Cavaliers were to him, but still the stone stands there, brooding on the hilltop.

The Hemlock Stone held a queer fascination for me as a child. We would often drive past it in our white Volkswagen Golf and I would watch it out of the back window – a silent, unmoving lump, looking down upon the road.

My mother told me that it had been kicked there by a giant. A more conventional form of the legend holds that the stone was hurled by no lesser person than the Devil himself. He was standing on a hill in Castleton, Derbyshire, at the time – more than 30 miles away – and was annoyed by the ringing of church bells at Lenton Priory on the outskirts of Nottingham. His throw was mighty, but his aim was poor. The stone fell 4 miles short of the mark and has stood there ever since.

Modern science gives a different account of its origins. According to geologists it is an outcrop of new red sandstone that was deposited in the Triassic period – some

200 million years ago. Due to a curious property of the rock, the lower sections are more prone to erosion than the upper sections. Therefore, it is both oddly shaped with a bulbous top and multicoloured. The top of the stone is still blackened by industrial pollution, whereas the bottom has been eroded clean by the wind.

Sadly, this erosion from the bottom means that the stone will eventually topple over. Hopefully that will not be for many centuries to come.

It has been suggested that the stone was quarried in the distant past and there has been much speculation about its role in pre-Christian religious rites. In his poem, Sutton peoples the site with ancient priests:

Well might the druid old bow down with awe,
And deem thee, when thy uncouth form he saw,
An alter cut by Nature's hand in stone
That her God might be worshipp'd thereupon....

He goes on to describe – in lurid detail – a sacrificial ceremony, performed with an accompaniment of harp music and a fug of incense smoke. This is, of course, a very Victorian fantasy. The information board, which stands next to the stone, freely admits that there is no direct evidence of druids ever using the site. This hasn't stopped many a commentator, besides Sutton, from linking it with ancient blood sacrifice. To this day, neo-Pagans visit the stone to conduct their (hopefully) more peaceful, modern ceremonies.

While standing on top of the hill, next to the stone, you should be able to see a labyrinth behind a high wall, on the opposite side of the road. This is a sundial maze and it is part of the garden at Bramcote Hall Park. It is well worth a visit while you are in the area.

22. Strelley Village

Were it not for the proximity of the M1 and the consequent rumble of its traffic, Strelley would be perfect. Horses graze in fields and ducks dabble in the village pond. A heavy pavement of well-worn stones adds a feeling of antiquity. These stones are known as the Monk's Way and may once have been linked to similar ones in nearby Cossall and Ilkeston. Legend has it that they originally formed part of a trackway that allowed medieval monks to travel between the various nearby priories and their commercial interests. It is said that each monk that passed that way would bring one of the slabs with him on the back of a mule, thus building the track piecemeal.

Others have speculated that the stones were laid more recently, as a means of transporting coal from the local collieries. Either way, they date back at least as far as the late eighteenth century.

The village church, All Saints, is a remarkable example of fourteenth-century architecture. While relatively plain on the outside, it is blessed with some wonderful

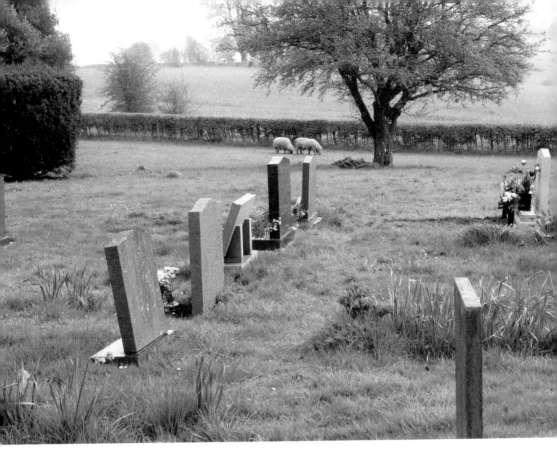

Sheep in the churchyard at Strelley.

interior carvings. These include a very unusual Sheela-na-gig, located on the undersides of one of the misericords.

Sheela-na-gigs are biologically graphic carvings of women, which are thought to be symbols of fertility. This one is especially fertile as she has leaves growing out of her ears and toes in the manner of a Green Man. At some point (possibly in the pious years of the nineteenth century) the vulgarity of the piece proved too much for people and the carving was vandalised. The 'naughty' bits have been – quite clumsily – removed.

Elsewhere in the church, you will find medieval stained glass, tombs of crusaders that are rich in symbolism and some of the finest brasses in the country. These are protected under a carpet, but the church organist was good enough to show them to me. There is also a remarkable altar screen that was taken from one of the local abbeys (no one knows which) and a very fine Victorian ceiling.

Exciting as all of this undoubtedly is, Strelley really comes to life – quite literally – in early spring. For about a month, from the middle of March onwards, a huge migration of toads takes place from the fields that are on one side of the single road that runs through the village, to the pond that is on the other. Thousands of warty adventurers make the dangerous journey, finding mates en route as they go to spawn. The mating ritual consists of the amorous male amphibian clambering onto the larger female's back and holding on tightly. There is a frantic beeping sound that is reserved for males that mistakenly try to hop onto another male – not an uncommon occurrence!

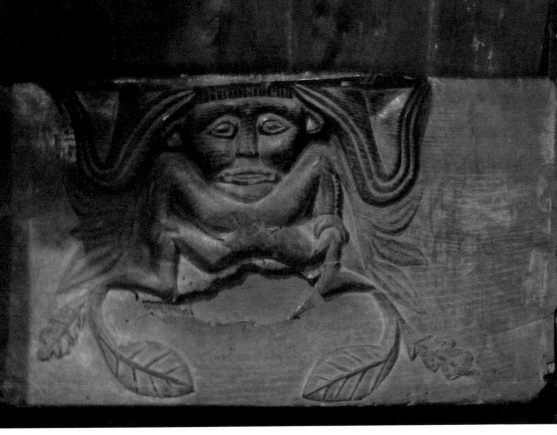

Evidence of Victorian vandalism in Strelley.

As the toads have to contend with both traffic and a rather high wall that separates them from the pond, an army of volunteers assembles each night – kitted out with torches and buckets – to assist with the migration. Can there be any more joyful sight than a bucketful of toads beeping in consternation by torchlight?

23. Oldmoor Woods

Just outside of Strelley village, along a bridleway that crosses the M1, is Oldmoor Woods. This is reached by following a gently sloping footpath with a Woodland Trust plaque on the gate. A hawthorn hedge lines the edge of the path and in springtime, patches of dog violets litter the grass.

The woods are lovely at any time of year, but especially in the spring, when they are carpeted with bluebells. The rumble of the motorway provides a constant drone – an incongruous stab of modernity in this sylvan Eden. Birds sing in the trees. A vigilant visitor might spot a Jenny wren, flitting low from perch to perch, or stop to watch a treecreeper hunting for insects. The knock and yaffle of a woodpecker carry through the still air. A spattering of wood anemones turn their faces to the sun on the far edge of the wood while, deeper in, twisted ivy sculptures hang from the trees.

Left: Bluebells in the Oldmoor Woods.

Below: A fallen oak, Oldmoor Woods.

Bees amble from flower to flower, while a careful view of the bluebell stems reveals a ladybird climbing steadily, unaware, no doubt, that her house is on fire and her children have gone.

And look, there! The darting rush of a hare among the undergrowth.

For those early rises among us, the dawn chorus here is a must: a slowly building symphony of cawing and twittering that almost drowns out the sound of traffic. From the edge of the wood, you can see the lorries speeding by, each one carrying a sad reminder of the work-a-day world that never sleeps, far away from the trees.

24. A. Plumb & Son

There are few things in the world that remain constant. A. Plumb & Son is one of the rare exceptions. It is a tiny hardware shop in my home town of Kimberley, and it has remained absolutely unchanged since my childhood in the 1980s. I am fairly sure that it has remained absolutely unchanged for a good many decades prior to that. To step over the threshold is to enter another, simpler, time.

Stepping back in time – A. Plumb & Son, Kimberley.

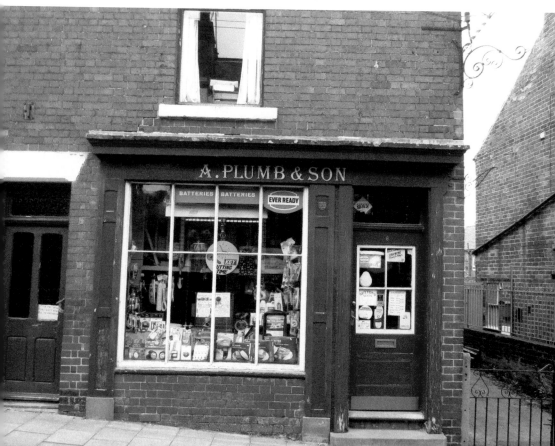

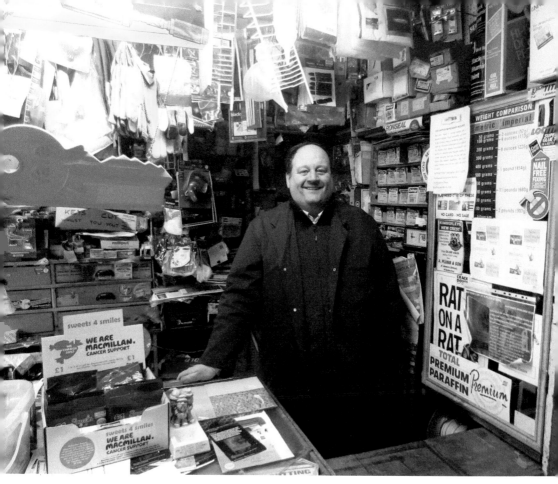

Ready to serve – Andrew Plumb in the family hardware shop.

The tiny, gloomy shop has a wholesome, practical smell all of its own. The floorboards are well worn and dusty and some mismatching chairs allow customers to wait their turn in comfort. Glass cabinets display everything that you could ever possibly need: coloured chalks, metal house numbers, bird seed ... A felt robin looks avariciously at tubs of meal worm, and a watch suitable only for the wrist of a giant hangs over the counter, telling the time.

If you are lucky you may catch the current Mr Plumb – grandson to the eponymous A. Plumb – practising his harmonica or tin whistle in the back room prior to coming to answer the shop bell.

The back room is a mystery to all, but anything and everything seems to be procurable from its depths: mousetraps, nuts, bolts, fork handles, four candles – you name it! This is a room that contains all of the treasures of the world. In there, I feel sure, Glenn Miller and the crew of the *Maria Celeste* sit upon pieces of the true cross and place bets on Shergar.

Across the cobbled road from the shop is another, although this one is only ever used as a store house, with the shop window displaying nothing but an aged mannequin who sits there – year in, year out – the centrepiece to an endless series of surreal vignettes that are constructed around him.

Plumb's is a gem that is very dear to Kimberley folk.

25. The Rolleston Graves/ Watnall Hall

Situated in an often-waterlogged field, commanding spectacular views of the surrounding countryside, the private graveyard of the Rolleston family is, at first glance, wholly underwhelming.

It consists of a small square area, hedged on all sides by thick holly bushes. Inside the hedge there are only a handful of trees and a good deal of brambles visible to the casual observer. If, however, you are brave enough to squeeze through a narrow gap in the holly and negotiate the thorns inside, you will be rewarded by the sight of the shattered memorials to one of the area's most powerful families. The gravestones are broken; the marble green with neglect.

The place has always held a special significance for me – I grew up very nearby – but it is only in recent years that I have learnt a little of its history. I can remember, as a child, that the graves were relatively well maintained. The hedge was higher then, almost forming a dome, and it was gloomy and scary inside.

Broken and forgotten – the Rolleston Graves.

The Rollestons were an 'old' family, with a long and distinguished history, but it is the father of one of the men buried here, Lancelot Rolleston Sr, that I find most interesting. He was a Tory MP for the Southern Division of Nottinghamshire (as it was then clumsily called) during the 1830s and 1840s, and the fact that he was a powerful and influential man can best be seen by the number of streets within the county that still bear his name.

For me, however, Lancelot Sr's most significant 'contribution' to history came twenty years before he entered Parliament. In the June of 1817, a number of textiles workers from Pentrich, Derbyshire, possibly incited by an *agent prevocateur*, began a march on London, intending to go via Nottingham. Conditions for the labouring classes were appalling in the second decade of the nineteenth century. Unemployment was high, wages were low and new methods of manufacture were forcing traditionally skilled craftsmen into abject poverty. The Pentrich Rebels (as they became known) wanted their grievances heard.

Then magistrate Lancelot Rolleston, upon hearing the news, had personally ridden to Nottingham to issue a warning and organise a stop to the march.

The rebels, led by Jeremiah Brandreth and fuelled by drink that they had consumed en route, were over 300 strong by the time they arrived at Giltbrook, Notts (now the home of the Ikea Retail Park). There they were met by a troop of the 15th Hussars Cavalry.

They were quickly dispersed, and the leaders were convicted of high treason. Executions followed. Rolleston had been instrumental in putting down one of the most significant revolutionary movements in modern British history.

The ancestral pile of the Rollestons, Watnall Hall, was a grand edifice, portions of which had been built during the reign of Henry VIII. With its reputation for grand balls and its association with the South Nottinghamshire Hunt, it seems a world apart from the lives lived by the Pentrich Rebels. It was demolished in 1962 and its remains are now covered by a housing estate. A gate post may still be seen, however, close to the Queens Head public house. How the mighty have fallen.

The mighty have fallen – the Rolleston Graves.

26. The Holy Well, Watnall

Not far from the Rolleston graveyard, on a little lane that forms a crescent leading off Trough Road, is the Holy Well.

Set off the road in a leafy grotto, the well has long since dried up, although a grated recess in the stone wall shows where it once stood. There is a small, metal plaque at the entrance to the grotto that reads:

> HOLY WELL
> ACCORDING TO FOLKLORE
> IN THE C.19, A SMALL BOY
> WHO LIVED OPPOSITE WAS
> SO ILL HE WAS NOT
> EXPECTED TO LIVE. HERE A
> PRIEST BAPTISED HIM
> AND HE RECOVERED.
> THEREAFTER THE WELL WAS
> CONSIDERED HOLY.

This story and the ivy-covered grotto are nice enough, but what makes the well so special is the attention lavished upon it by … someone. The grotto is – and always has been, for as long as I can remember – decorated with garden gnomes, as well as little statues of owls, fairies, squirrels, teddy bears, ducks, etc. It is lovely in an understated, childlike way.

I have no idea who has taken it upon themselves to do this, but it makes a perfect memorial to a sick little boy and a well that cured him long ago.

A charming little legend – the Holy Well.

27. Beauvale Priory

Beauvale Priory is now a shattered ruin, a few broken walls of reddish yellow stone and the remnants of medieval masonry cannibalised and mingled in with the structure of the adjacent farmhouse.

In 1535, the prior of Beauvale, along with two other martyrs (including the former prior, St John Haughton) were arrested on the orders of Thomas Cromwell. They had refused to accept Henry VIII as the head of the Church of England, and for that they were tortured to death. A Catholic pilgrimage to the site is still held in early May each year to mark the event.

With all of that in mind, what better place to go for a cup of tea?

Set in the midst of what D. H. Lawrence once described as 'the country of my heart', Beauvale Priory is almost picture perfect. Dense woodland and rolling green fields surround it on all sides. The ruins of the priory are complimented by what are, mostly, charmingly rustic farm buildings (the large, corrugated iron and concrete barn is, perhaps, less aesthetically pleasing), while turkeys, chickens and a tame peacock roam around freely.

The large, stone gatehouse has been converted into a tearooms that sell an array of cakes and light meals. Antlers hang on the walls (possibly from the wild deer that live in the woods) and, in winter, a log burner in the wide hearth kicks out some tremendous heat.

For the beer lovers among you, there are regular beer festivals held at the priory, with a wide selection of drinks available, as well as craft stalls, morris dancing and music from local bands. There's even a place to put up a tent. This will save you a long stagger down dark country lanes to the nearest bus stop.

Martyrs at Beauvale Priory.

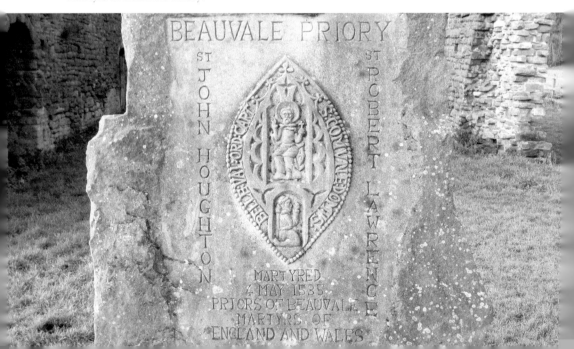

And if you really want to push the boat out and sleep in a proper bed, there are even a couple of holiday cottages on site. Why not make a full week of it while you're here? It'll give you ample opportunity to have a look at some of the other things in this book!

28. Eastwood

Boston, Massachusetts, famously has a red line running along its 'sidewalks' – a trail that will lead the visitor around some of the more spectacular sights of this New England city. Who can resist the sweet golden-brown image of Boston in the fall?

Thousands of miles away, and grey, even in the height of summer, is the small former mining town of Eastwood. Like Boston, it has a line that runs along its pavements, although this one is suitably faded, blue and has gaps where workmen have dug bits of it up. Occasionally, if you choose to follow the line, you will see small metal discs embedded in the tarmac. On each disc is the image of a bird – a phoenix no less – rising from among the flames. Look around you and you will start to see the symbol everywhere – on lampposts, litter bins and even built into the brickwork on the sides of houses.

This is the emblem adopted by the author D. H. Lawrence – Eastwood's most famous son. Like the phoenix, he arose from the ashes of the collieries that

Follow the blue line and look out for phoenixes – Eastwood.

surrounded him. The blue line – the only one of its kind, outside of Boston – runs between key locations in his early life. By following it, you may visit the house where he was born (now a rather splendid museum) or take in a view of the fields and woodland that he once described as 'the country of my heart' (a sentiment that is repeated, ad nauseum, in the literature that is optimistically aimed at attracting tourists to the area).

Local businesses have, of course, been keen to cash in on the controversial author's legacy – pubs, tearooms and even a veterinary surgery have all named themselves after the man and his works. One wonders what he would have thought of all of this. He openly wrote of his dislike of the place and his contemporaries – if local tradition is to be believed – had no love of him.

Whatever the feelings of people in his own time, Lawrence is certainly a favourite of locals now and he has an army of passionate devotees across the globe. I grew up a couple of miles away from Eastwood and was once forced, by a complete stranger who had discovered where I came from, to read highlighted passages from Lawrence. My accent was the closest that he had ever come to hearing the lines read by the author himself and the avid listener fell into, quite vocal, raptures.

It takes all sorts to make a world.

D. H. Lawrence's
birthplace – Eastwood.

29. The Erewash Canal

The Erewash Canal meanders along the border of the two counties of Nottinghamshire and Derbyshire, stitching a seam as it runs from one to the other.

The wondrous network of canals that once criss-crossed the nation is not what it once was. Following the transfer of most of Britain's freight to the faster and more reliable motorways in the middle of the last century, many have fallen into disuse and been filled in. Others that were once a hive of industry and activity are now the preserve of jolly boaters and waterfowl, while the towpaths have been given over to walkers and cyclists.

The Erewash Canal offers a long, relatively flat stretch that runs from Langley Mill, which is just over the county border in Derbyshire, as far as Trent Lock. Here, it joins the River Trent and, in recent years, the riverside path has been opened up, allowing pedestrians and cyclists to follow it past Attenborough Nature Reserve via Beeston Marina (where there is a café and a canal heritage museum) and all the way into Nottingham. Keep going and you will eventually end up at Trent Bridge and a spectacular view of Nottingham Forest's home – the City Ground.

It is a very long walk if you intend to do the whole thing, but in my younger days I would cycle it regularly, and it is perfectly manageable in a couple of hours.

Still waters on the Erewash Canal.

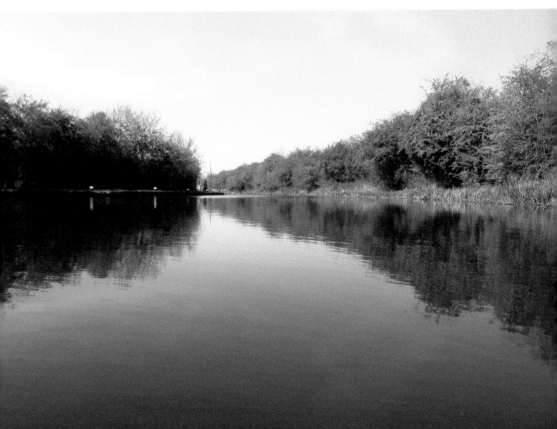

Above: The lock-keeper's cottage at Sandiacre – the Erewash Canal.

Below: The arteries of England – the Erewash Canal.

A serene resident of the Erewash Canal.

Along the way, you pass a number of notable sights, including Bennerley Viaduct (you can get on top of the structure from the towpath, by climbing up a steep slope) and the lock-keeper's cottage at Sandiacre. This is a very picturesque spot for a break. Many a lazy hour have I spent here, dabbling my feet in the lock while eating my sandwiches. The cottage is opened to the public once a month (the third Saturday) and is well worth a visit.

There are also numerous examples of the area's industrial past, with a number of old factory buildings with towering, red-brick chimneys – in various states of dilapidation – lending an air of decaying grandeur to the canalside.

As you go, make sure to keep your eyes peeled for a turquoise shimmer over the water. There are kingfishers along certain stretches of the canal and a brief glance of one is sure to make your day.

30. Bennerley Viaduct

The Bennerley Viaduct stands alone, in the middle of nowhere. It spans a brownfield site, littered with concrete foundations and rusting bits of metal, and connects a non-existent railway line in Nottinghamshire with another – similarly defunct – one

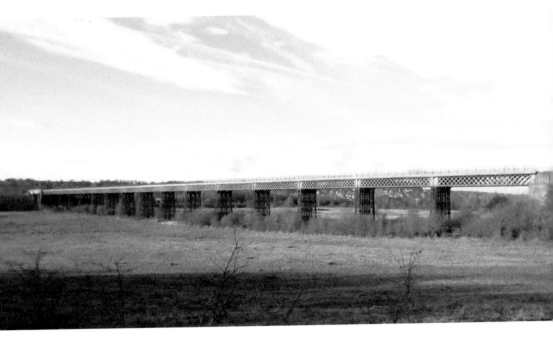

Bennerley Viaduct.

in Derbyshire. Robbed of its raison d'etre, it stands as a majestic tribute to the faded glory of Victorian engineering.

The Grade II listed structure is vast. It towers over its surroundings – a great black wrought-iron behemoth. When viewed from below, the observer is not only impressed by its scale, but by the sheer, reckless bravery of the graffiti artists who have scrawled on some of its, seemingly inaccessible, portions.

Finished in 1877, the structure owes its listed status, in part, to its unusual design. At the time, most viaducts were built of brick, but here an iron latticework was used to bring down the weight and reduce the possibility of subsidence, caused by local mining.

And it certainly was built to last. It survived being bombed in the First World War (the nearby, Derbyshire town of Ilkeston famously suffered an air raid by Zeppelins) and was later saved from demolition when the train line, of which it was a part, was decommissioned. Apparently, the ironwork would have proved too expensive to remove.

Majestic as it is when viewed from below, the real joy of the structure comes from walking along it. Access to the top of the viaduct can be gained at either end, by scrambling up a steep muddy slope (this is most easily done from the Derbyshire end, via the Erewash Canal towpath). Standing at one end of the structure, you can really get a sense of its sheer scale, as rusting girders stretch away from you in an apparently endless procession towards the vanishing point.

From here, you can take in the full vista of the surrounding area – rural, residential and industrial as it is. As the abandoned dry ski slope, railway lines, church towers and gliding birds jostle for your attention, you may reflect that while it is not a pretty place, it is not without its own, gritty charm.

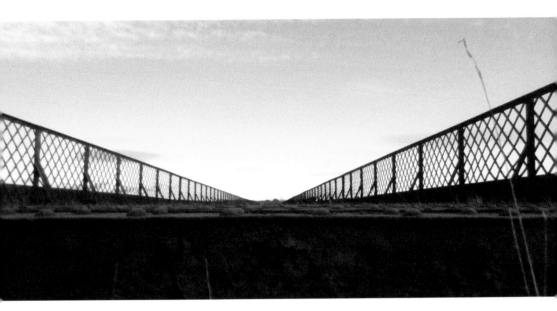

On top of Bennerley Viaduct.

31. Bestwood Winding Engine House

'Of course, for your generation the great legacy of the pits are the Country Parks,' the old, ex-collier told me, in reference to the number of green spaces that had sprung up in recent years on the sites of former mines.

'Not a bad legacy,' I opined. I am the first male member of my family for generations never to have worked down the pit and I am eternally grateful of the fact.

'I'm not so sure.' He looked sad for a moment, no doubt remembering the purpose, dignity and camaraderie of his trade. The old miners are a proud people. I had felt a little bit ashamed when he had asked me what I did for a living. I've never gone to the bath house to wash away the black dust after a hard day at the coal face. Writing a guidebook is not really 'man's work'.

We were standing on the top floor of the Bestwood Winding Engine House – a fabulous Victorian construction that operated for the best part of a century, raising coal from the bowels of the earth to fuel the endless demands of empire and industry.

A magnificent relic from the age of steam, the engine still runs – although, of course, there is no longer anything for it to lift. On Saturday mornings, a team of volunteers happily show visitors around and talk them through the history and mechanics of the place. Hard hats are dealt out and the smell of oil hangs heavily in the air as great wheels turn and a mannequin in period dress mans the controls.

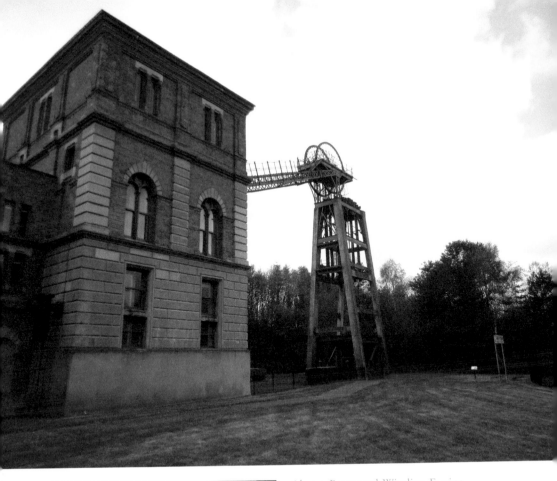

Above: Bestwood Winding Engine.

Left: Relics of the industrial age in Bestwood.

Apparently, it is possible to get out and up to the top of the headstocks. From up there, the miner assures me, you can see all of the old collieries in the local area. It sounds spectacular, but whether faced with the stifling blackness of the pit or the lofty heights of the machinery that tower above it, I am a coward to the core.

With the weight of my disapproving ancestors on my shoulders, I left the Engine House and went over to the nearby building where they sell tea and cake – the latter of which are made by the local WI. I stopped to peruse the jars of home-made marmalade and Wildlife Trust leaflets and to thank my lucky stars that I had not been born a few decades earlier.

32. Papplewick Pumping Station

Like George Green (see 14. Green's Windmill), Thomas Hawksley was a local lad whose ideas would go on to change the world.

There was a cholera epidemic in the middle years of the nineteenth century and Nottingham, with her reliance on the polluted waters of the Trent and the River Leen,

Poetry in motion – Papplewick Pumping Station.

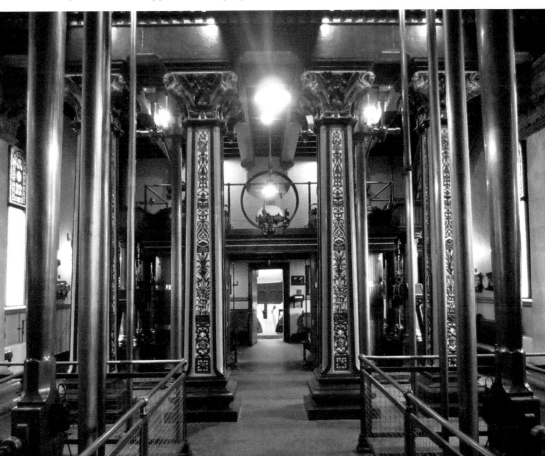

The denizens of fresh water – lovingly created details at Papplewick Pumping Station.

was prone to the ravages of the killer disease. It was Hawksley who realised that the porous sandstone upon which the area was built acted as a perfect filter, cleaning out impurities and leaving pockets of safe drinking water underground.

Hawksley was going to exploit the principle of the household well on an industrial scale.

In 1880 he built a huge, underground reservoir near the village of Papplewick. His plan was to construct a steam-powered pumping station adjacent to the site. Events conspired against him, however, as the Nottingham Corporation took on the responsibility of providing clean water to the populace. The construction of the station fell to one Marriot Ogle-Tarbotton – a man who would add exquisite beauty to Hawksley's eminently practical vision.

The Papplewick Pumping Station began operating in 1885. It is a tribute to industrial ingenuity but also to a deeply Victorian sense of the aesthetic. A powerful machine of the steam age the pump may be, but it has been lovingly decorated with ornately carved fishes, river plants and wading birds – all things that are closely associated with fresh water. As the project came in under budget, the excess money was spent on stained glass (again depicting fishes, water lilies, etc.) and terracotta tiles.

The station was decommissioned in the 1960s (a fully automated, electric station is still operational on the site), and is now open to the public as a museum – largely

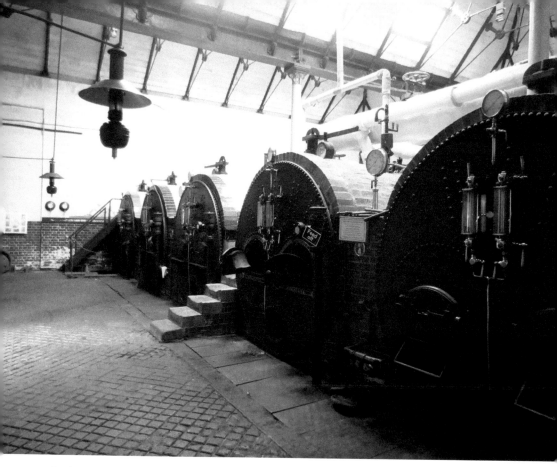

Boilers at Papplewick Pumping Station.

volunteer run. It is open on Wednesdays and Sundays and visitors are welcome to enjoy both the artistic charms of the pump and the attached tearooms.

The real wonder of the site, however, can only really be seen on steaming days. These take place on bank holiday Sundays and Mondays, as well as on a few other selected days throughout the year. On the steaming days, you can see the huge, iron boilers being stoked with coal. As they heat up, the main pump room comes to life. It is a surreal wonder to stand among those masterful carvings and experience the room moving around you, as though it were a living creature. Pistons slide and the machinery spins and rocks in a way that is almost nautical.

You can also see the Linby Colliery winding engine – one of the engines that once provided coal for the pump – and visit Hawksley's original reservoir. This has long since been emptied of water and is now a high-vaulted, subterranean space, resembling nothing so much as an underground cathedral. The acoustics are incredible: I once played a drum down there and a single beat became a roll of thunder.

Steaming days are usually themed – 1940s, steampunk, classic cars – and entertainment is provided. The prices may seem a little steep, but the tickets are good for a year, so you can keep coming back to fully imbibe the wonders of this incredible building.

33. Annesley Old Church

You may have noticed that in this book I have shown a bit of a penchant for medieval ruins. Annesley Old Church is a perfect illustration of this. It was built by the Annesley family, on the site of an earlier Norman church, in 1356. It then served as a working church for more than 500 years. In the 1870s, a new church, All Saints, was built to serve the burgeoning mining community that had grown up in the village. The old church was still used for occasional services until the Second World War, before being abandoned. Since then, it has fallen into a state of ruination.

The church door still hangs on its hinges, although it no longer separates the outside from the in – all is open to the sky and weeds abound around the ancient interior. Gravestones stand, mossy and overgrown. Adjacent to the church stands the similarly dilapidated Annesley Hall. Apart from the nearby hum of traffic, one could almost feel that you were standing at the end of the world.

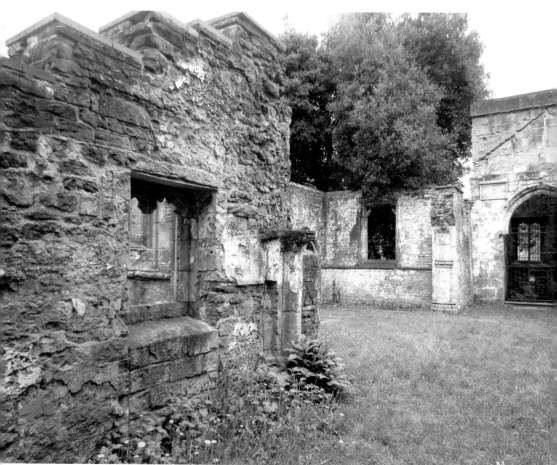

Atmospheric ruins – Annesley Old Church.

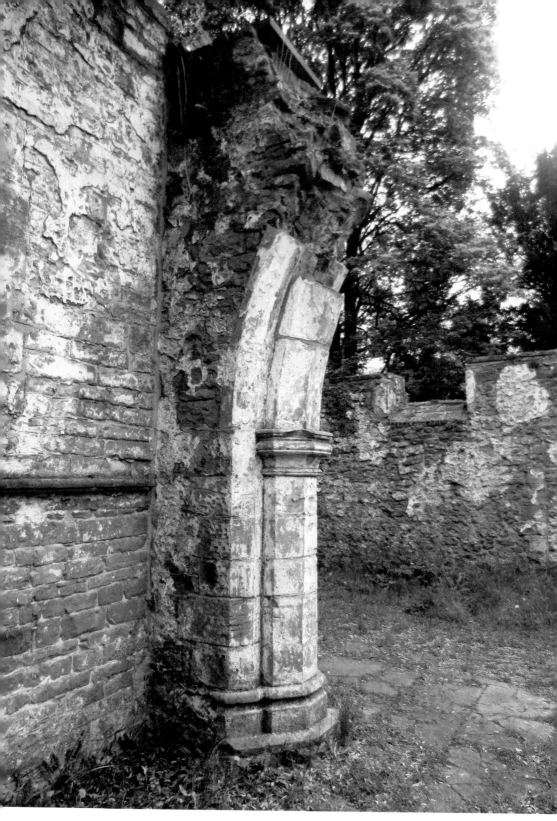

The remains of Annesley Old Church.

34. Newstead Abbey

Newstead! fast-falling, once-resplendent dome!
Religion's shrine! repentant Henry's pride!
Of Warriors, Monks, and Dames the cloister'd tomb,
Whose pensive shades around thy ruins glide,

Hail to thy pile! more honour'd in thy fall,
Than modern mansions, in their pillar'd state;
Proudly majestic frowns thy vaulted hall,
Scowling defiance on the blasts of fate.

George Gordon, Lord Byron (*c.* 1817)

Thus wrote Lord Byron of his ancestral seat, prior to his being forced to sell it to an old school friend to cover the oceans of debt that he had incurred through his famously wanton lifestyle.

The abbey had been built in 1170s and had been granted to one of Byron's ancestors – Sir John Byron – by Henry VIII, following the Dissolution of the

The home of a genius – Newstead Abbey.

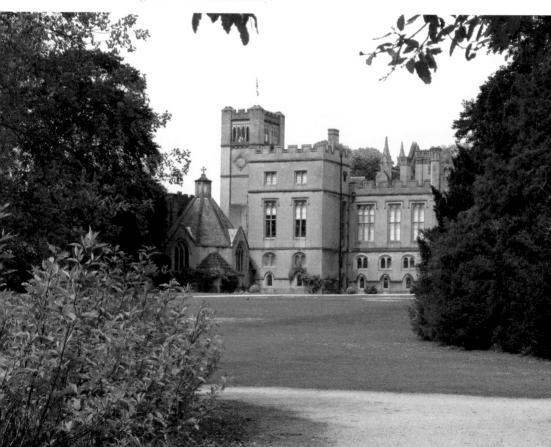

Monasteries. Sir John, who was famed for his magnificent beard, was the first in a long line of colourful lords to hold the abbey, including 'Foul Weather Jack', 'Mad Jack' and 'the Wicked Lord' William Byron. Mock sea battles were fought on the abbey lake, men were killed in duels and sexual scandals were on the lips of many a local gossip.

When in 1808 George Gordon – the man we tend to think of as Lord Byron – moved in with his tame bear, his beloved dog Boatswain and a small army of nubile serving girls, he was merely the last of many 'mad, bad and dangerous to know' Byrons that had been resident there.

Today, it is still easy to see why the place had such a hold on the young poet's imagination. The ruins of the abbey and the attached mansion house are set among gorgeously rolling acres. Woodland, lakes, ancient trees and waterfalls surround the tumbledown splendour of the place. One can imagine Byron limping here beside Boatswain (whose magnificent tomb can still be found close to the house), his mind awash with Gothic literature and the poems of the older Romantics.

Walled gardens, lawns containing statues of grinning satyrs and a dreamy Japanese water garden all lend an *Alice in Wonderland* feeling of strangeness to the grounds. This otherworldliness is only magnified by the frequent calls of the peacocks that parade around freely. Everywhere there are tunnels, hidden arbours and sheltered nooks. One might easily spend a whole day exploring and not see it all.

Beautiful gardens at Newstead Abbey.

Japanese Water Gardens at Newstead Abbey.

35. Blidworth Cradle Rocking Ceremony

Candlemas – 2 February – was once regarded as the end of the Christmas celebrations. The shortest day may be long past, but it is a dark, cold season none the less. The bare, muddy fields and washed-out sun may encourage melancholy thoughts of mortality in even the most unpoetic of souls, but it is at this very gloomy time of year that the candles are lit to celebrate a new life in the Nottinghamshire village of Blidworth.

The Church of St Mary of the Purification has stood there, in one form or another, since the fifteenth century. Much of what is there today is of a more recent date,

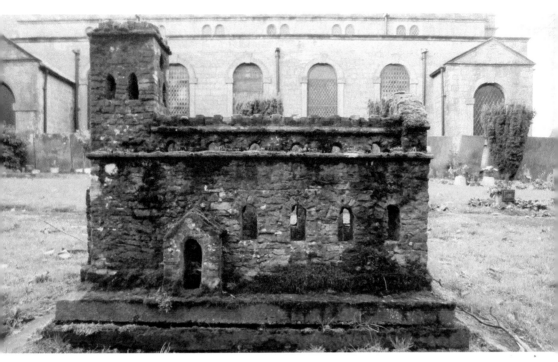

Above: Little church, big church – Blidworth.

Below: The rocking cradle – Blidworth.

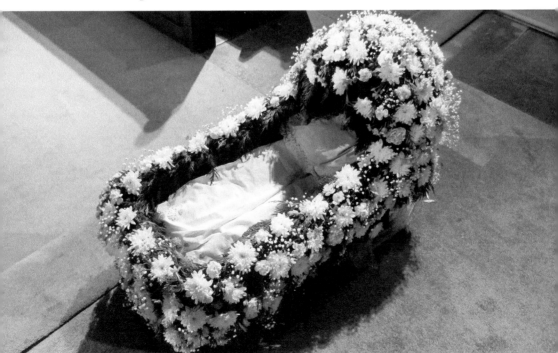

but some of the older walls have been re-erected in the churchyard and there is a model of the old church, moss covered, in among the gravestones. There is also a marker showing the – highly suspect – final resting place of Robin Hood's Merry Man, Will Scarlett.

The cradle rocking ceremony was once common to all churches dedicated to St Mary of the Purification. It is a symbolic recreation of the events of Christ's own purification at the temple. In 1600, amid the frantic anti-Catholic zeal that possessed the Protestant authorities, the ceremony was suppressed. It has since been revived twice – once in the nineteenth century and then again in 1923.

On the first Sunday after Candlemas, a baby boy born to Christian parents, closest to Christmas Day and within the parish of Blidworth is put in a cradle and rocked. The cradle is decorated lovingly with white and yellow flowers. There is a church service, some hymns are sung and candles are lit. The rocking is only very gentle – it is only a very small baby. With that out of the way, there is tea and cake and an opportunity to take photos.

It is a great, and much sought after, honour to be rocked. There is a plaque at the back of the church bearing the names of all of the previous 'rockees'. Several of them attend the service each year to welcome the newest of their number to the fold. I had attended the service on several occasions and have been thrilled to meet two elderly men, both of whom had been the focus of rocking ceremonies in the 1930s.

This ceremony is a highlight of the local social calender. The church is always full of smartly dressed parishioners and the beaming parents tend to make an effort to look dapper in their Sunday best. The cake's not bad either.

36. Cresswell Crags

Of all the gems in this book, none perhaps is quite so apt to make one reflect upon the nature of things as Cresswell Crags.

There have been people – or, more accurately, hominids – occupying the site for around 60,000 years. When viewed on that scale, the martyred monks of Beauvale Priory and the craftsmen who carved the Green Men in Southwell Minster are our near contemporaries.

Cresswell Crags is an impressive limestone gorge. Huge rugged rock walls reflect off the still surface of the water that lies between them. Set into these are a number of natural caves, of varying depths. These caves were the seasonal homes of various Stone Age peoples – from early Neanderthals to members of our own species in the Upper Palaeolithic and Mesolithic epochs. There is also evidence of their use in more recent historical times. Here, at one time, the hippopotamus wallowed and the bison grazed, early man shivered in the cold depths of the ice age and the Roman sandal trod.

The gorge is situated just a stone's throw away from the more comfortable dwellings of twenty-first-century man – a continuity of occupation stretching back through nausea-inducing numbers of lifetimes.

In 2003, a staggering discovery was made – cave art. Aeons ago, unknown artists used natural features in the rock to create images of various animals and birds. These are the most northern examples of their kind to be found in Europe and the only ones to be discovered in the British Isles.

One can amble around the crags for free, although the caves themselves are gated off. Regular tours are available from the large visitor centre, discreetly situated far enough away from the gorge to avoid spoiling the ambiance. The site is, of course, a favoured destination for school trips and in term time it is full of groups of eager hard-hat-wearing children, keen to learn about the lives of the cavemen who had lived there.

Despite this, in quiet moments, when one looks up at the rocks that now play home to innumerable, beady-eyed jackdaws, it is possible to roll back the millennia and ponder for a moment upon the enormity of time, the endurance of the human spirit and the fleeting transience of our own existence.

Since the dawn of man – Cresswell Crags.

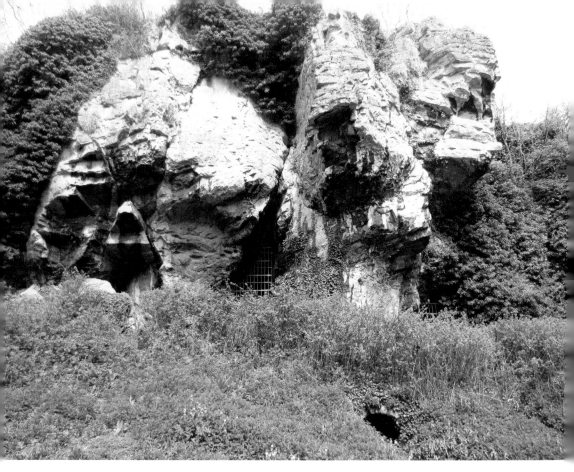

Once the hippo, the hyena and early man lived here – Cresswell Crags.

37. Rufford Abbey Country Park

So poacher bold as I unfold,
Keep up your gallant heart,
And think about those poachers bold,
That night in Rufford Park.

From 'The Rufford Park Poachers'

For many people, Rufford Park is associated with the famous folk song quoted above. The ballad tells of a gang of poachers engaging in a pitched battle with the park's gamekeepers in order to 'make a fight for poor men's rights' – a battle that left one of the keepers dead and the miscreants condemned to be transported to Australia. It is a true story, apparently, the events having taken place in the early 1850s.

Today, the park – which is centred around the ruins of an abbey that was first founded in the twelfth century – is one of Nottinghamshire's most popular visitor attractions. The abbey building is little more than a pleasantly ramshackle

centrepiece to the rolling gardens and grassy spaces that surround it. There is a large lake, an orangery (now used as a space for selling garden ornaments and flowers), an old icehouse, acres of woodland and even a collection of animal graves. These mark the final resting places of various dogs, and a racehorse, that were beloved by the family who, for many years, owned the estate – the Saviles.

The gardens are littered with ornamental pieces. To my mind, the most fascinating of these is a small model of the Temple of Diana at Lake Nemi (fans of Sir James Frazer's *The Golden Bough* will be particularly intrigued by this). In 1885, relics from the Roman temple were excavated by Lord Savile and the pieces were brought back the England. Many of them now reside at Nottingham Castle. Ceramic votive offerings, like those found at the site, are housed within the miniature temple and may be seen through narrow slots in the walls.

Not far from this sculpture is a wonderful adventure playground that will keep the little ones amused for hours.

Amusing to young and old alike is the ford, which can be viewed at the far extremity of the park, next to Rufford Mill. Crowds gather around the fence overlooking it, to watch cars drive through the water and send up huge jets of spray. I can't drive, so I've only ever been a passenger in a car going through the ford, although I can assure you that this was even more fun than watching the splashes from the outside.

Another delightful ruin – Rufford Abbey.

Relics from Nemi – Rufford Abbey.

38. The Wellow Maypole

The small village of Wellow is situated close to Sherwood Forest. It is chocolate-box pretty, an idyllic vision of rural England with thatched roofs and a public house overlooking the green.

'Nothing out of the ordinary there', I hear you cry. 'Quaint rural villages are ten a penny.'

Yes, but Wellow is the only one to permanently play host to the UK's largest maypole!

And what a spectacular pole it is. Standing at a jaw-dropping 60 feet, it towers over the green, dwarfing the buildings that stand around it. Though worth seeing at any time of year, it is, of course, best experienced when in use.

May Day celebrations were once widespread and were often debauched and drunken affairs. Many a country lass was blessed with a baby to nurse when the following February came around. Sentimental Victorians – looking back to the Merry England that was rapidly disappearing in the wake of industrialisation and mass urbanisation – were quick to reinvent the 'May Games' in an altogether prettier

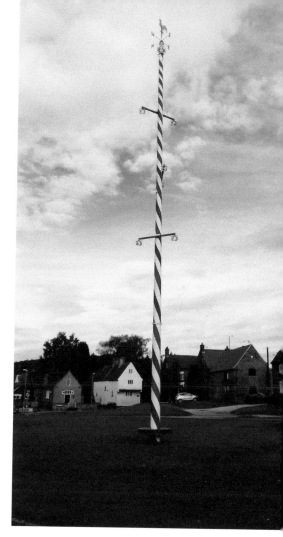

Right: The biggest in Europe! Wellow Maypole.

Below: At the heart of the community – Wellow.

and more restrained form. Hence, the modern maypole dance, complete with ribbons and pristine white frocks, was born.

Wellow Maypole Day takes place on the late May bank holiday each year. Visitors are treated to a quintessentially English afternoon. There is tea and cake in the village hall, beer in the pubs, Punch and Judy shows and morris dancing on the green and – if you are lucky – a Lancaster Bomber flying by overhead.

The main focus, however, is the maypole dancing. Seemingly endless teams of small girls are brought out to dance around the maypole, weaving the long ribbons into intricate and carefully choreographed patterns. All of this is presided over by the May Queen and her attendant entourage of bugler, posy bearer and other lackeys (there has to be something for the boys to do).

If a slice of ersatz Merry Olde England is what you're after, this is the place for you.

39. Sherwood Forest

'... Here the green meads, in their loveliest prime,
Exhale their May-tide incense to the sky;
And here the wild birds send their hymns on high;
And nodding woods extend their darkening gloom;
And winding streams in harmony pass by;
And myriad heath-flowers, congregated, bloom;
And corn-fields waving mock famed Araby's perfume.'

So wrote Robert Millhouse – the artisan poet who is Nottingham's answer to John Clare – in his epic poem *Sherwood Forest* (1827). Millhouse evokes the sheer beauty of this famous, ancient woodland. In early times, the forest covered much of the county. Even now – though much reduced – it is a splendour to behold.

For Millhouse, it was his muse. For most people, the world over, it is the haunt of the legendary Robin Hood and his outlaw band of Merry Men.

The famous anti-hero of innumerable old ballads and the frolicsome keeper of the May games has, from very early on in his career, been strongly associated with Sherwood Forest. It is easy to see why. The dense woodland, filled with ancient English oaks, would have been the perfect place for the bold outlaw and his Merry Men to hide from the machinations of the wicked Sheriff of Nottingham. Among the bracken, they could lie in wait for passing churchmen and dignitaries, ready to relieve them of their wealth.

Today, the wild intimidation of the forest has been tamed. Visitors are unlikely to be ambushed by outlaws. In fact, this is widely discouraged. Now, instead, there is a rather pleasant visitor centre and café, run by the RSPB, in conjunction with the Woodland Trust and others. Here one can buy wooden swords, felt Robin Hood hats and a slice of coffee and walnut cake. There is also an adventure playground and a craft shop.

A maze of paths lead through the forest, and it is a joy to wander aimlessly along them, allowing your feet to lead the way as birds chitter in the canopy above you. You may allow your eyes to pass over tiny clusters of wildflowers that spring up out of the forest floor or to the bracket fungus that clings tenaciously to the bark of the silver birch trees.

Inevitably, your feet will take you to the Major Oak. This stately and ancient tree – the enormous weight of its boughs held up by wooden supports and its trunk hollowed with age – is reputed to have once been the home of Robin Hood. A former holder of the title 'Tree of the Year' and officially recognised as 'Britain's Favourite Tree' in a 2002 poll. This giant among oaks is a magnificent ambassador for the arboreal community.

Among the many family events that Sherwood Forest plays host to each year, perhaps the most popular is the week-long Robin Hood Festival. Taking place each summer (check online for exact dates), this free festival brings together a wide array of reenactors, musicians, storytellers, crafts people and conservationists to celebrate the legend of Robin Hood and the forest that is so closely associated with his name.

Honey Fungus in Sherwood Forest.

Robin Hood's house? The Major Oak, Sherwood Forest.

40. The Laxton Open Field System

Laxton is a strange – though not unattractive – place. At first glance, it may seem ordinary enough. It is a quaint little red-brick village, dominated by a fine church with gargoyles around the roof. There's a pub, a small village green and even an old red telephone box (with a telephone in it!). There's a small hill on the outskirts of the village, which marks the site of an eleventh-century motte-and-bailey castle. What could be more predictably English than that?

Well, on closer inspection, you will notice the signs on the walls of many of the buildings. These give the names of the small farmsteads that comprise a sizeable portion of the village. I've never seen so many separate farms in such a small area and little wonder, for Laxton is unique. It is the only village in England that still has a medieval-style 'open field' system.

Whilst the rest of the country suffered from the (frankly disgraceful) process of enclosure, Laxton's agricultural set-up remained unchanged. The fields are divided into strips, which are worked by the village's farmers. This is overseen by a court leet – a judicial body that meets every three years to ensure that the boundaries between the strips are respected and that crops are rotated.

This is an odd survival from the past and one that I hope will continue for many centuries to come!

Above: The village
church, Laxton.

Right: Doing it
the old-fashioned
way – Laxton.

41. Southwell Minster

There has probably been a church on the site of Southwell Minster since the seventh century and a close inspection of the building will show the successive waves of building work and modernisation that have gone on ever since. Saxon masonry can still be viewed inside the minster, alongside gorgeously detailed medieval carvings and some thoroughly modern stained glass. Its scale is truly staggering and a full description of everything that can be found there could fill this volume several times over.

It stands, double spired, in the midst of an attractively green and rolling churchyard. Interestingly ancient gravestones litter the grass.

Adjacent to the minster, on the side furthest from the road, is the Archbishop's Palace. This is now mostly in ruins, although the great hall still survives. It is worth popping in, if only to see the State Chamber. The fabulous beams of the vaulted ceiling are a wonder to behold.

In 1530, Cardinal Wolsey was at the Archbishop's Palace – desperately trying to stave off his fate, having failed to secure a divorce for Henry VIII. He didn't survive long after his visit and a cast of his death mask can now be seen at the nearby Saracen's Head Hotel.

Southwell Minster.

Southwell Minster – 1620!

Upon entering the minster itself, you are likely to be overwhelmed by the sheer scale of the space. The vertigo-inducing ceiling arches above you are a testament to the ingenuity and dedication of the long dead builders and stonemasons who worked on it. Closer to the ground, the stonework is no less awe inspiring in its intricacy and you could happily spend hours in its contemplation without having fully appreciated every feature.

However, the most enchanting glory of the minster is to be found in the chapter house. Located at the end of a short and intricately decorated corridor, this almost circular room is breathtaking. The roof soars overhead, unsupported by a central column and high enough to allow for lofty windows that let in an enormous amount of light. Seats line the walls – each one bearing the name of one of the parishes that fall under the diocese of the minster. These are surrounded by some of the most wonderful medieval stone carvings still in existence. Detailed and ornate plants sprawl and bloom across the walls. In among them can be seen a myriad of Green Men – faces surrounded by (and often disgorging) leafy branches. One of them, perhaps uniquely, is depicted as holding a garland of branches in his hands. Other figures – human, animal and a mixture of the two – can also be found, each one a lovingly crafted triumph of the stonemason's art.

Even for those of us that do not possess religious convictions, a visit to Southwell Minster and its magnificent chapter house is a humbling experience.

Above left: Unusually (perhaps uniquely) a Green Man depicted holding the leaves, Southwell Minster.

Above right: One of many Green Men in the chapter house at Southwell Minster.

42. The Bramley Apple

There can be few things that an Englishman holds in higher esteem than the apple crumble. Served hot with a liberal pouring of cream, its simplicity can only be rivalled by the innocence of the pleasure that it gives. Dear to us it may be, but who among us as ever stopped to wonder who is to thank for this paragon of earthly delights? Well, that honour may go to a number of people connected with the historic town of Southwell.

In 1809, Mary Ann Brailsford – who was a child at the time – planted some apple pips in her garden. From these a tree began to grow. The cottage was later bought by a local butcher – one Matthew Bramley. When, in 1856, a local nurseryman – Henry Merryweather – asked if he could take cuttings from the tree so that he could

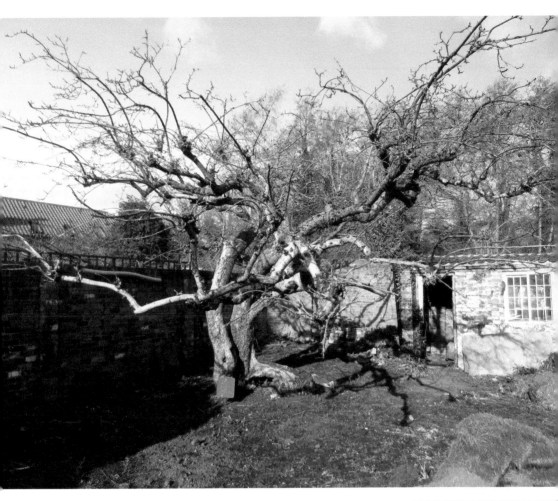

Above: You can thank this tree next time you're tucking into a nice apple pie.

Right: A tree with a blue plaque! The Bramley Apple.

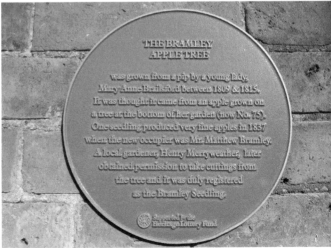

THE BRAMLEY
APPLE TREE

was grown from a pip by a young lady,
Mary Anne Brailsford between 1809 & 1815.
It was thought it came from an apple grown on
a tree at the bottom of her garden (now No. 75).
One seedling produced very fine apples in 1837
when the new occupier was Mr. Matthew Bramley.
A local gardener, Henry Merryweather, later
obtained permission to take cuttings from
the tree and it was duly registered
as the Bramley Seedling.

Supported by the
Heritage Lottery Fund

sell the apples, Bramley agreed, on the condition that the fruit should bear his name. The rest, as they say, is history.

More than 200 years on from its germination, the tree is still standing and still bearing fruit (although it is now looking rather sickly due to a nasty fungal infection). In recent years, it has been in the running for the nation's favourite tree, been awarded a blue plaque and even appeared in a commemorative stained-glass window in the nearby minster.

Not bad for a few pips scattered in a garden.

43. Newark Castle

Newark, Newark! It's a wonderful town!

Newark-on-Trent is a bustling market town that contains all that you could hope for in such a place. An impressive market square acts as a hub, from which numerous cobbled lanes lead the visitor from pub, to second-hand bookshop, to bakery. Over all of this looms a large and very imposing church.

A fortress in ruins – Newark Castle.

The first signs of spring in the gardens of Newark Castle.

These are all worthy of a visit in their own right, but the true gem of the town is the ruined twelfth-century castle that stands – majestically shattered – on the banks of the Trent. A large portion of it is still upright, a rambling grey indication of what must in its day have been an awe-inspiring building.

The jagged remnant is now flanked by pleasant gardens, complete with a bandstand, formal flower beds and informal sprays of gaily coloured crocuses in the springtime. A serene enough spot for a picnic. As children clamber onto what is left of the fortifications and parents bask on the grass, it is easy to forget the long history of the place.

It was at Newark Castle that King John met his end, after eating a 'surfeit of peaches'. What a way to go!

For the reenactors among you (you know who you are), Newark Castle is probably most famous as the site of three sieges during the Civil War. Standing,

as it does, on the banks of the river, the castle was of vital strategic importance. It was held by the Royalists throughout the conflict and was never taken by force. It was only on Charles I's orders that the castle surrendered.

This strength was to be the castle's undoing. Parliament ordered its demolition, to prevent it from being used as a stronghold in future conflicts.

I ponder this as I sit on a bench, looking at the flowers and opening a paper bag that I had got from one of the bakeries in town. As I eat, I contemplate more pressing matters: is it possible to die from a surfeit of tiffin?

44. The Castle Barge

Moored on the banks of the Trent, just a couple of minutes' walk from Newark Castle, is a barge with a difference. Or do I mean a pub with a difference?

The Castle Barge has been operating since 1980 and still has the original owners. The covered cabin is a wonderful space (free to hire) and attracts plenty of families. Children,

A floating pub! The Castle Barge, Newark.

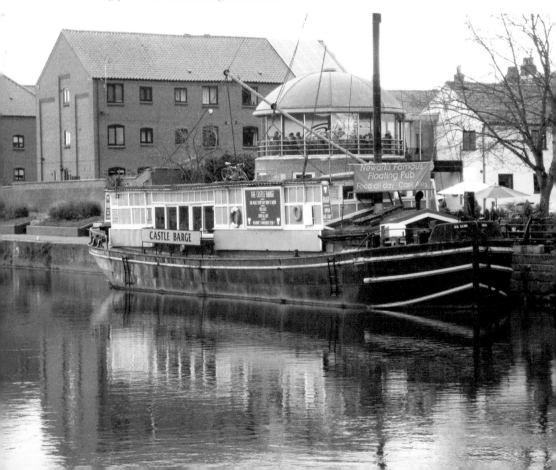

All aboard the Castle Barge, Newark.

including my own, are usually excited at the prospect of a glass of lemonade and a (very affordable) meal, taken onboard ship with a grand view of the river. The furnishings are suitably nautical and your kids will soon be splicing the daydreamy mainbraces and heading for the Spanish Main.

Below deck, it's strictly adults only. Here, you'll find the bar, which serves the usual fare as well as a few real ales. Here, you'll also be able to peruse the cakes that they have on offer. Again, there is a distinctly nautical theme, with plenty of mysterious objects, outside of the ken of poor, landlocked lubber such as myself, on display.

You may be a long way from the sea, but this is perfect place to come and have a drink while stoking your maritime pretensions.

45. Mattersey Priory

With no parking or vehicular access to the private land on which the priory stands, one is forced to leave the car in Mattersey village and walk for a mile along a dusty track to reach the monument. The suspension-wrecking potholes will probably make you thankful that you have done so, as will the yellowhammers that flicker among the hedgerows as you go by.

The stroll will be rewarded by the sight of some romantically ruined walls and bits of medieval masonry, which once formed part of the ecclesiastical establishment and now belong to English Heritage. Access to the site is free of charge.

The monastery was established in the latter part of the twelfth century. Much of the original structure was destroyed by fire in 1279 and the ruins that can be

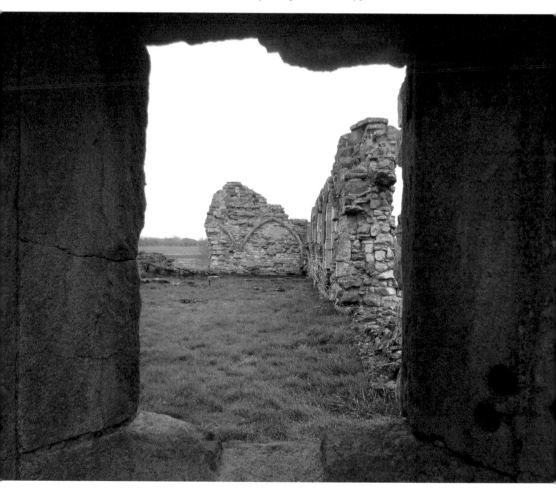

Henry VIII has a lot to answer for! Mattersey Priory.

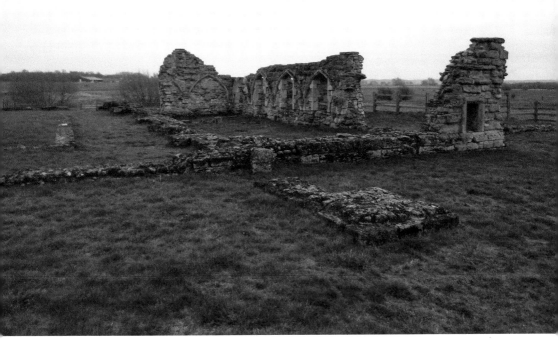

It'll be nice when its finished – Mattersey Priory.

seen today were mostly constructed after this date. Following the Dissolution of the Monasteries, the building met a similar fate to that of countless others across the country. Now only some arched windows and a few foundations hint at what would formally have been the home to half a dozen Gilbertine Cannons.

The Gilbertine Order had the honour of being the only one that was entirely English. It was founded by Saint Gilbert, a parish priest from nearby Lincolnshire who lived to the incredible age of 106! Sadly, the Gilbertines, like the priory, did not survive the dissolution, although there have been recent – very low-key – revivals.

The ebb and flow of English history and the gay flutterings of the yellowhammers should give you plenty to ponder on the long walk back to Mattersey.

46. The Barrister's Book Chamber

The north Nottinghamshire town of Retford has many charming features to attract a passing visitor: from the cannon that was captured at Sabastopol, to the attractive marketplace and the enticing aroma of fish and chips that wafts along the high street. For me, however, the main draw is the Barrister's Book Chamber.

Above left: Ah, time for a nice cup of tea and a quiet read – the Barrister's Chambers.

Above right: Mystery books – the Barrister's Chambers.

Owned by a qualified barrister with a passion for the written word, this is a cosy bookshop, specialising in antiquarian, vintage and second-hand books. The prices are reasonable, and the atmosphere is decidedly cosy. The walls are literally covered with books, from old *Rupert* annuals and much-loved copies of the *Little Grey Rabbit* books to obscure volumes on the law and salacious 'Whodunnits'. An armchair here and a chaise lounge there only add to the homely feel.

Peppered about the place are 'blind date' parcels – books wrapped in brown paper. There is no clue to the author or the title, only a gift tag offering a one-sentence description of the plot. Such a risk! Is it a Margery Allingham or is it a Jeffrey Archer!?

The staff are welcoming and the tea and cake that are supplied in the attached tearooms are sublime.

Having found a suitable book (I eschewed some of the weightier legal tomes in favour of a well-thumbed copy of Elizabeth Beresford's *The Wombles*), I parted with my £2 and headed out into Retford. Time for a bag of chips!

47. Beckingham Marshes

Beckingham Marshes may not, at first glance, be particularly prepossessing. The long straight road that goes by it, carrying an endless stream of articulated lorries, brings you to what appears to be a large windowless building.

This is 'the Willow Works', a community project housing meeting rooms and playing host to the local history society. The building itself was once used for drying willow, for the making of baskets, chairs and other useful commodities. This was the principle industry in the area until way into the twentieth century, and it is sad to realise that this last remaining building of its type. All of the windows are on the north side – facing away from the road – a precaution against the bright, southern sun drying out the withies too quickly and making them brittle.

The Willow Works kindly allows visitors to the RSPB reserve across the road to use its car park. The nature reserve is set in unspectacular countryside that, situated as it is at the far extremities of the county, reminds one more of Lincolnshire than of Nottinghamshire. Flat land is all around and wide ditches run along the sides of each fields. A power station dominates the skyline, and before it runs a busy main road.

Undaunted, my family in tow, and armed with my granddad's old field binoculars, a bird book and a pocketful of scrumped greengages, I set off across the cow fields that comprise the reserve to see what I could spot.

There are a number of displays in the fields – fenced off to protect them from the cows. These contain information boards, archaeological finds and examples of things that you may or may not see. Perhaps most impressive of all is the (possibly Neolithic) napped flint that had been found on the site.

Very little else of interest caught our eyes – the sky being populated solely with crows and seagulls, both of which are plentiful in Nottingham.

In the second field, there is a large platform with a mounted telescope on it. It was as we reached this that the excitement began. A brown hare! The information boards said that they were plentiful in the area, and here was one bounding away across the field. Suddenly it froze, keeping perfectly still, and camouflaging itself among the bracken. The telescope – which was a lot better than my binoculars – showed its face in amazing detail.

It was then that my wife spotted two buzzards circling in the sky.

A panoramic view – Beckingham Marshes.

A lookout post – Beckingham Marshes.

Pleased with our observations, we headed back to the car. The first field was now full of goldfinches, swooping on mass from shrub to shrub and singing their joyous, trilling song.

At the entrance to the site, we spotted a butterfly flitting from dandelion head to dandelion head and stopped to watch it.

Despite its bleak appearance, the reserve had been a thoroughly enjoyable. It was time to pop over the county border for a cup of tea in Gainsborough.

48. Gunthorpe Lock

It is difficult to know what to say about Gunthorpe Lock and the surrounding stretch of the River Trent. It is not the sight of any great historical moments, nor is it blessed with architectural wonders. It is merely a lovely, relaxed place to stroll, and what higher praise can be sung than that?

On hot summer afternoons the luscious greens of the trees that stand on the bank beyond the weir are reflected in the shimmering water. Fishermen cast off, dogs splash about and paddling children marvel at the tiny minnows that dart around their feet.

The sun on the water – Gunthorpe Lock.

Fishing and paddling – enjoying the water at Gunthorpe Lock.

Occasional pubs and cafés provide victuals for visitors and boaters from the marina may be seen, tinkering with their craft.

If, like me, you have held a lifelong love *The Wind in the Willows*, I can think of no finer place to play at being Ratty and Mole. On the long stretches of grassy bank, you can picnic at ease and watch the ducks – 'up tails all!'

49. Gotham

Three wise men of Gotham,
They went to sea in a bowl,
And if the bowl had been stronger
My song would have been longer.

(Traditional English nursery rhyme)

Really? There are two gems in a book on Nottinghamshire that are directly related to Batman?

To the uninformed (and the voice of a satnav) the village of Gotham seems to share its name with the fictional city of old comic book and camp 1960s TV programme fame. In fact, it is pronounced 'Goat'em' and was famous throughout the land, long before the Caped Crusader ever took to fighting crime.

Since at least as early as the fifteenth century, in cheap pamphlets and bedtime stories, the exploits of the Wise Fools of Gotham have been entertaining children and adults alike. The story goes a little something like this:

Once upon a time, King John, who was travelling in the area, was due to pass through the village. At that time, any road that the king travelled upon became a public highway. Horrified at this prospect, the villagers decided to put him off. To this end, they decided to feign idiocy.

What follows is a catalogue of imbecility, all of which was timed to be observed by the king's servants. Among other things, the villagers were seen to be raking the pond to catch the reflection of the moon or putting a hedge around a cuckoo to stop it from flying away with the springtime. Presumably, this would have worked if only they had laid a taller hedge!

Warned of how stupid the locals were, the king took a different road and the people of Gotham were spared from having a public highway through their village.

So famous were the stories of the Wise Fools of Gotham, that the village's name was used by Washington Irving in a satirical publication, to poke fun at New York City. This in turn inspired its use in the late 1930s comic strip, *Batman*.

There is now a weathervane, at the top of a long pole, in the middle of the village. All around the pole are depictions of the foolish activities of the locals, while Batman climbs up it, using one of his iconic 'bat-ropes'.

Not far from the village, in an area of woodland at the top of a hill, you can still find the mound upon which the cuckoo was supposedly hedged. Intriguingly, this has been excavated and is actually a Neolithic burial mound.

Wise fools and caped crusaders – Gotham.

50. The Great Central Railway

The first thing to greet you is the heavy, slightly acrid smell of burning coal. The yard of Great Central Railway, situated on the edge of Rushcliffe Country Park, looks more like a building site than a museum. This is an industrial, working space, dominated by the collection of steam engines and carriages that stand as gargantuan monuments to the nation's engineering past.

Having purchased a day ticket, my daughter and I boarded the train. It consisted an old-fashioned chain of carriages, made up of the separate compartments that I had only ever experienced in classic films. Instantly, I was in the Romantic world

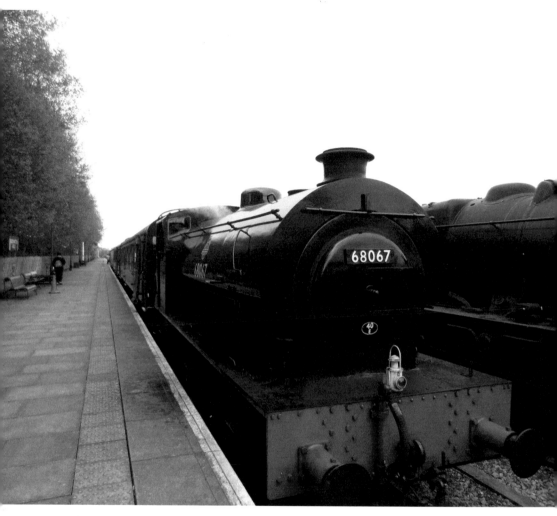

Full steam ahead – the Great Central Railway.

of Arthur Askey and Hercule Poirot – a world where Angela Lansbury might vanish at any second.

I was astounded by how comfortable the compartments were. Long years of being herded into the utilitarian vehicles provided by modern rail companies had conditioned me to think of trains as things to be endured. Here, sitting in the carriages of yesteryear, I was experiencing, for the first time, the twin luxuries of legroom and well-upholstered seating.

The train whistled, steam swirled passed the compartment window and we were off along the 10-mile stretch of track between Ruddington and Loughborough in north Leicestershire. And what a pleasurable trip. People waved at us as we passed by and my daughter took great delight in the horses, streams and rabbit holes that glided by the window.